D0045564

BY THE BOOK

BY THE BOOK
STORIES AND PICTURES

DIANE SCHOEMPERLEN

BIBLIOASIS
WINDSOR, ONTARIO

FIRST EDITION

Library and Archives Canada Cataloguing in Publication

Schoemperlen, Diane, author
 By the book : stories and pictures / Diane Schoemperlen. -- First edition.

Issued in print and electronic formats.
ISBN 978-1-927428-81-8 (bound).--ISBN 978-1-927428-82-5 (ebook)

 I. Title.

PS8587.C4578B9 2014 C813'.54 C2014-902923-3
 C2014-902924-1

Edited by Dan Wells
Typeset by Chris Andrechek
Cover designed by Gordon Robertson

Biblioasis acknowledges the ongoing financial support of the Government of Canada through the Canada Council for the Arts, Canadian Heritage, the Canada Book Fund; and the Government of Ontario through the Ontario Arts Council.

PRINTED AND BOUND IN USA

Table Of Contents

This book is dedicated to Kim Jernigan
(editor extraordinaire!)
who believed in this project from the beginning.
Love from me

INTRODUCTION

IF **I** HAD A LITERARY MANIFESTO it would begin with this quote from Octavio Paz's 1973 volume of essays, *Alternating Current:*

> The most perfect and vivid expression of our time, in philosophy as well as in literature and art, is the fragment. The great works of our time are not compact blocks, but rather totalities of fragments, constructions always in motion by the same law of complementary opposition that rules the particles in physics.

As Paz sees it, the fragment is the form that best reflects the ever-changing realities of our modern lives, each fragment being like "a stray atom that can be defined only by situating it relative to other atoms." It is all a matter of relationship and interaction.

My as-yet-unwritten manifesto would also include this quote from Charles Simic's 1992 book *Dime-Store Alchemy* on the life and work of the maverick surrealist Joseph Cornell:

> The collage technique, that art of reassembling fragments of pre-existing images in such a way as to form a new image, was the most important innovation in the art of the twentieth century.

Collage is the most accommodating and unpredictable art form, an often playful arrangement of visual fragments that produces a final collective image that is always much more than the sum of its parts.

This book is a symbiotic combination of fragments and collage, fraternal twins in both form and process. Reduced to the simplest explanation, they both operate on the principle of putting apparently unlike or unconnected things together and seeing what happens.

The seven stories in this collection are based in various ways on old texts from the late nineteenth and early twentieth centuries. In the tradition of the *objet trouvé,* especially found poetry, these stories take the form of a found narrative: an imagined, expanded, and embroidered rearrangement of the original material. Each story is illustrated by coloured collages I have created myself.

The title story, "By the Book or: Alessandro in the New World" is exactly what its subtitle promises: "An Unlikely Tale of Translation, Time Travel, and Tragic Love." More narrative in nature than the following six pieces, it is the story of a young man's adventures after emigrating from the Old Country to the New World. His story is interwoven with and revealed by exact excerpts from a book originally published in 1900 called *Nuovissima Grammatica Accelerata: Italian—Inglese Enciclopedia Popolare,* a guidebook intended for the use of Italian citizens moving to the United States at the turn of the twentieth century.

The source books for the other six stories include such volumes as *A Catechism of Familiar Things* (1854), *Seaside and Wayside Nature Readers* (1887), *The Commonly Occurring Wild Plants of Canada: A Flora for Beginners* (1897), *The Cyclopedia of Classified Dates With An Exhaustive Index* (1900), and *The Ontario Public School Hygiene* (1920).

In fact, these six stories are not exactly stories at all. Rather, each piece is a construction or a deconstruction or a reconstruction (or maybe all three). I did not exactly write any of the lines in any of them. I discovered them (like a continent), mined them (like gold or coal or potash), unearthed them (like bones), excavated them (like archaeological artifacts), solved them (like a crossword puzzle), deciphered them (like a secret code), organized them (like a filing cabinet or a clothes closet), choreographed them (like a ballet or maybe a barn dance), arranged them (like a symphony or a bouquet of flowers). In each case, I picked out the pieces (like gold nuggets

from gravel or maybe like worms from the garden), shuffled them many times (like playing cards), and then put them together again (like a jigsaw puzzle, ending up with a picture entirely different from the one on the front of the box). I have used each sentence exactly as it appears in the original text, except in a few cases where I have changed pronouns and verb tenses for consistency.

The collages were constructed in the old-fashioned way by the traditional cut-and-paste method with real paper, real scissors, and real glue. This tactile experience was a vital part of the creative process that could not have been achieved by manipulating the images and text digitally. The computer was important though, as I was able to scan pages from each old book and reproduce them multiply to serve as the collage backgrounds and to use bits of the actual texts in the collages themselves.

Both the texts and the collages here are based on layers, bits and pieces of this and that from here and there, placed side by side, piled one on top of the other, until something entirely new and unexpected emerges, generating what Paz called "the contrapuntal unity" of fragments connecting, reflecting, and deflecting in variable relation to each other. The creative possibilities offered by this intersection of the written word and the visual images are unlimited, the juxtaposition of these two elements producing frequently startling explorations of connection and disconnection, resonance and dissonance, collision and collaboration.

By The Book Or:
Alessandro In The New World

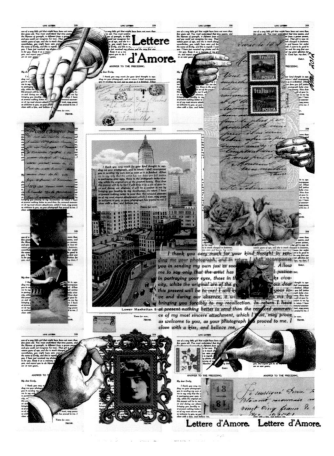

AN UNLIKELY TALE OF TRANSLATION,
TIME TRAVEL, AND TRAGIC LOVE

From:

**Nuovissima Grammatica Accelerata:
Italian—Inglese Enciclopedia Popolare**
by Angelo de Gaudenzi
(New York: Italian Book Company, c. 1900)

This Italian—English handbook was primarily intended for the use of Italian citizens immigrating to the United States. It includes sections on grammar, vocabulary, nomenclature, arithmetic, history, citizenship, and the American Constitution. It also includes a large number of sample letters to be used in both business and personal correspondence and many dialogues to be used in everyday situations such as discussing the weather, looking for work, getting a hair cut, buying groceries, and visiting the doctor.

All lines set in boldface in the story are taken directly from this text, complete with spelling and grammatical errors. Only the names and a few minor details have been changed for consistency.

It was agreed that my endeavours should be directed to persons and characters supernatural, or at least romantic, yet so as to transfer from our inward nature a human interest and a semblance of truth sufficient to procure for these shadows of imagination that willing suspension of disbelief for the moment, which constitutes poetic faith.

—Samuel Taylor Coleridge, *Biographia Literaria* (1917)

AS FAR AS HE KNEW, Alessandro was the first member of his extended family to leave the Old Country and make his way to the New World. Aunts, uncles, cousins (first, second, third, and twice-removed), they had all stayed, if not exactly where they started from, then at least little more than a good stone's throw away.

Alessandro first announced his plan to emigrate at a large family dinner held to celebrate a distant cousin's recent engagement. Maria, the charming young woman now sporting a hefty diamond ring on her left hand, was actually *not* so young anymore and perhaps not so charming either, and the family had all but given up hope that this day would ever come. Consequently, they were all there, overjoyed and relieved, dozens of them crammed into his parents' house, plowing through a groaning table of beef, ham, chicken, fish, pasta, potatoes, salads, fruit, cheese, and a dozen different desserts. Clearly there were no concerns here about calories or cholesterol.

The entire family was noisily surprised when Alessandro made his big announcement. There were gasps and sputterings and such a general hue and cry that the babies began to squall and the dog (a malodorous yellow mongrel alternately called Suzy, Stinky, or Squirt) who'd been hiding under

3

the table patiently hoping for scraps, began to whimper and leap around the room in wild-eyed canine alarm.

All around the table, forks full of food were frozen midway between overloaded plates and gaping open mouths. They were collectively gob-smacked. Only the betrothed couple, Maria and Roberto, remained silent, being more than a little put out at having their matrimonial thunder thus summarily stolen by Alessandro's unprecedented news.

In the midst of all this brouhaha, nobody noticed at first that one of the old uncles was choking on a grape, and then he had to be dramatically thumped many times on the back to dislodge it. There was talk of the Heimlich maneuver but, thank God, it didn't come to that. The offending grape (red, seedless) was finally liberated and spurted out of the old uncle's throat with a velocity and momentum much like that of the champagne corks popping from the several bottles (but without the audible *pop*) that had been opened an hour earlier to toast the newly affianced couple. The projectile grape proceeded to land squarely on Alessandro's plate, the ruby jewel in the crown of a mound of garlic mashed potatoes. There was immense relief all around and a brief smattering of applause.

The assembly then regrouped, dished out second, third, and fourth help-ings, and returned en masse to the matter at hand: Alessandro's intended defection. There were certainly no admonitions here about talking with your mouth full. In the final analysis, it appeared there was not one among the family who thought Alessandro's proposed emigration a good idea.

His mother especially was distraught at the prospect of this youthful (mis)adventure. He was, after all, her one and only. Although he was now ostensibly an adult, twenty-five years old, confident, intelligent, ambitious, and independent, he was still her baby and always would be. After his announcement at the dinner, she was tearful for many days, could hardly look at him without succumbing to a fit of copious weeping with much clutching and patting of her beleaguered maternal breast. She was not at all impressed by his fancy talk about it being a new century, a new millen-nium, about his burning desire to become a new man in the New World.

In the ensuing weeks, she spent more than one day in bed going through the old photo albums which showcased Alessandro on page after

shiny page. There he was: a scrunch-faced infant with his soft-skulled head in her hands, a curly-haired toddler on his father's knee, a sturdy and vigorous boy on his shiny red tricycle. There he was: a handsome young man in a navy blue gown and mortarboard, blushing at his high-school graduation. There he was: her beautiful beloved boy. Her grief was so extravagant, it was almost as if he had just up and died on her.

His father, a stoic and taciturn fellow by nature who spent most of his time either at work, in the garage, or watching sports on TV in the basement, tried, in a somber man-to-man manner, to talk him out of it. But Alessandro would not be swayed. His father gave up quickly enough and retreated to his customary stance of being seldom seen and even more seldom heard.

Eventually both parents resigned themselves to their son's imminent departure, consoled somewhat by the time-honoured notion that the New World was indeed the land of opportunity (not to mention milk and honey), the land where health, wealth, happiness, and charming successful progeny were all but guaranteed to everyone who worked hard and applied themselves diligently to the pursuit of the North American dream. Maybe Alessandro would become a multi-millionaire who could look after them in their rapidly approaching old age.

On the day of his departure, his father gave him a dry-eyed, thin-lipped manly hug and his mother cried all over him at the airport. While his father gave him some extra cash for the journey, his mother secretly slipped a book into his carry-on bag. Alessandro didn't actually discover the book until he was well on his way. The plane was somewhere over the Atlantic Ocean by then, the meal had been served and cleared away, darkness had fallen, and all around him the other passengers were taking off their shoes, adjusting their blankets and lozenge-sized pillows, settling in to watch the movie or have a little sleep. Alessandro was rummaging through his bag for a piece of gum when he found the book.

Over a hundred years old, it was called *Grammatica Accelerata* and it appeared to have been much used. Its pages were soft and yellowed, the edges of its green covers were worn bare, and its spine was hanging on now by only a few brittle threads. It looked to be some kind of handbook, a detailed

instruction manual for life in the New World, consisting of four hundred pages of vocabulary lists, verb conjugations, pronunciation guides, sample dialogues and letters for everyday situations, both personal and commercial.

Pasted inside the front cover was a small sepia-toned photograph of a young man and below it a signature in script of almost calligraphic perfection. The book had apparently belonged to his mother's great-great-grandfather, Alessandro's namesake, his very own great-great-*great*, of whom he had always been told he was the spitting image. Alessandro himself could see the obvious resemblance, especially around the eyes (dark and deep) and the chin (square and strong). His nose could have been (had been!) called "patrician," his cheekbones "chiselled," and his brow "intelligent." Being a humble young man, of course Alessandro would never use these words to describe himself (at least not out loud).

All through the book there were margin notes inscribed in the same precise handwriting as the signature, and faint pencil arrows and stars marking particular vocabulary lists.

Man Apparels: Night shirt. Morning-gown. Evening dress. Felt hat. Straw hat. Jacket. Overcoat. Pants. Cane. Snow-shoes. Stirrups. Spurs.

Woman Apparels: Chemise. Girdle. Crinoline. Corset. Apron. Parasol. Bonnet. Veil. Fan. Shawl. Nosegay. Furs. Satin shoes. String of pearls.

Apparels for Both Sexes: Shoes. Socks. Hat. Opera glass. Gloves. Garters. Soap. Watch. Silver watch. Gold watch. Pin. Pocket. Vamp.

Further on in the book, in the part called **Nomenclatura**, more words and phrases in the tailoring sections were underlined and check-marked.

Lady's Tailor: Needle. Pin. Hook and eye. Silk. Wool. Thimble. Tape measure. Pressing iron. Figure.

Gents Tailor: Pants. Sleeve. Collar. Shears. Button. Button hole. Lining. Spool. Scissors. Sewing machine.

Alessandro recalled having been told that his great-great-great-grandfather had worked for some time as a tailor when he was young, so these notations made sense.

A few brief but undoubtedly handy dialogues had also been marked.

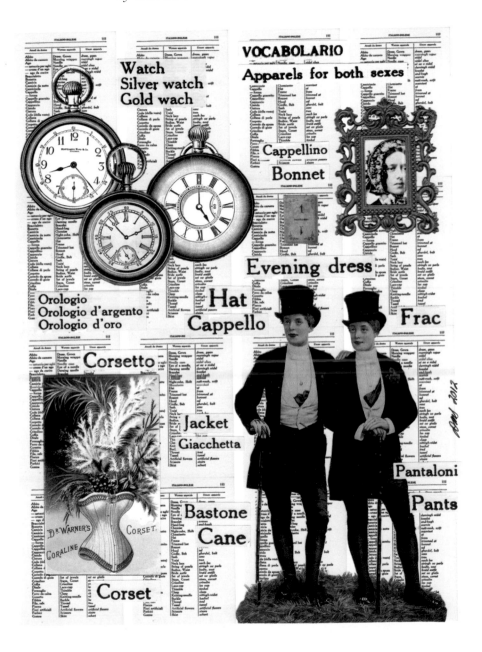

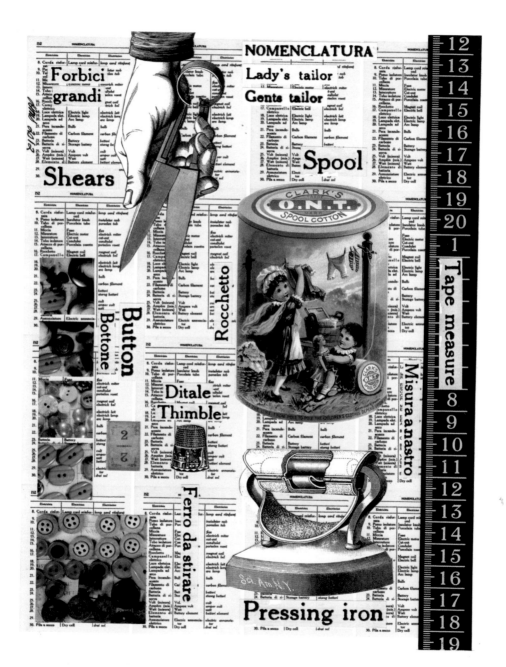

Do you wish meat or cheese?
Please give me a piece of cheese.

Will you take a glass of wine?
I would rather have a glass of beer.

Can you lend me a hammer?
I can.
I cannot.
Have you a knife in your pocket?
I do.
I do not.

Have you seen my horse?
Yes, I have.
No, I have not.

He has lost his two children.
He has broken his right arm.
She has cut her finger.

How is your health?
I am not quite well.
I am sorry to hear that you are not well.

What is the matter with you?
I have a headache.
I have sprained my left foot.

Do you speak English?
I find it very difficult to pronounce the *th*.
That is the most difficult sound in the English language.
It can be learned only by much practice.

Stay a little longer.
No, thank you, I can't stay.
Why you hurry so?
I have business to attend to. Another time I will stay longer.

Why do you do that?
Because you told me so.

Shall I do it now?
Shall I come tomorrow?
Shall we go to supper?

Will he come today?
Will she do it again?

Good day, mister.
Mistress, good night.

Clearly this forefather had also dreamed of becoming a New World man. In all the stories young Alessandro had been told about his esteemed great-great-great, this had never once been mentioned. Whatever deep dark secrets other families conspired to keep close to their hearts, obviously this was his.

Alessandro took this revelation to mean that his own decampment to the New World was not so much his decision as his Destiny.

Below his great-great-great-grandfather's signature there was an address. It was written in red ink, underlined heavily several times, marked with many red stars and a single imperative complete with three exclamation marks: *GO!!!*

Despite the age of the book, Alessandro soon found it to be very helpful. After the plane landed, he went directly to the immigration office. There he had all the right answers ready when the grim-faced agent began his

interrogation. He scarcely looked at Alessandro as he questioned him, but apparently they were both working from the same script.

What is your name? Of what country are you? How old are you? Are you single? Are you married? Have you any children? Did you ever broke any laws? Have you ever been in prison? Are you an anarchist? Do you belong to any secret society who teach to disbelief in organized government? Have you any money? Where do you go? Have you the railroad ticket?

After the agent had completed his extensive list of questions, he stamped the required paperwork and signed it with an authoritative flourish. Apparently Alessandro had answered everything correctly and passed the test.

At what time does the train leave? he asked the agent.

You must be ready at four o'clock.

Alessandro checked his watch. It was now 3:30 p.m.

Where is the Depot? he asked.

The agent pointed impatiently to a sign that Alessandro had not noticed. The arrow on the sign pointed down a long corridor. In what seemed like only moments Alessandro found he had arrived at the Depot.

Are you the conductor? Is this the emigrant's train? he asked of a tall stern man in a uniform and cap, a man who could well have been the emigration agent's twin brother.

Tickets, gentlemen! the conductor replied, although Alessandro was the only gentleman in sight.

In which car must I go? Alessandro asked, consulting the book while peering down the shadowy tunnel in which the train waited. It appeared to have only one car. This struck Alessandro as odd and the tunnel itself was unlit and eerie, like something out of a scary movie. But he was a brave young man and onward he strode, with no reason to imagine that he was about to embark on a trip far beyond the bounds of geography, history, and time.

Hurry up, the train starts! the conductor cried, giving Alessandro a not very gentle shove up the stairs of the train car. **All aboard!**

Alessandro was surprised to discover that he was the only passenger.

📖

After he got off the train, rather than going to a cheap hotel as he had originally intended, on impulse Alessandro went instead to the address written in the book below his great-great-great's signature. It was located just a few blocks from the train station, an easy walk even with all his luggage. It turned out to be the address of a rooming house set up especially for young men in his position. The building was a typical brownstone, tall and narrow, wedged between two much larger and flashier buildings. It was so nondescript that it would have been easy enough to walk past without even noticing it. The only indication of its identity was a small sign above the door that said simply ROOMS in white letters against a black background.

Alessandro dragged his increasingly heavy suitcase up the front stairs and went in. The man at the front desk was old and shriveled, scrawny and stoop-shouldered, wearing a wrinkled white shirt with a red bowtie and blue suspenders that held his baggy brown pants well up over where his pot belly would have been if he'd had one. Hunched over a large ledger, he was squinting short-sightedly at long columns of figures, resorting frequently to the use of a magnifying glass the size of a dinner plate. Alessandro stood patiently before him for several minutes before he closed the ledger and looked up.

What can I do for you? the old fellow asked with a sigh.

Once again Alessandro found the book served him well.

Will you help me? he asked.

Certainly, with the greatest pleasure, the old fellow replied in a tone that gave no indication of pleasure whatsoever.

Have you any rooms to let?

Yes, sir, I have several.

I want a furnished room. I would like to have a room on the first floor.

I have just one, but it is rather large.

Can I see the room?

The old fellow came out from behind the desk and walked stiffly down a hallway to the left with Alessandro following. When they reached an open doorway on the right, the old fellow gestured and Alessandro peeked inside. It was a lovely large room but the price given when Alessandro asked was well beyond his means.

I think it is too dear. I cannot afford to pay so much. Have you any other rooms cheaper?

Certainly, you can have a small one. Will you have the kindness to follow me upstairs?

Slowly and with much aggrieved sighing, the old man led Alessandro up several flights of dark and narrow stairs.

The room on the third floor was indeed quite small, but it was very clean and bright, with plain white walls, a blue-and-white tiled floor, and one large window overlooking the street. It contained a single bed, a four-drawer dresser, a good-sized wardrobe, and a very comfortable-looking faded green armchair. On the tiny bedside table there was a clock and a reading lamp. The old fellow explained that there was a communal kitchen on the first floor and a large institutional-style washroom at the end of the hall.

Alessandro was very pleased with the arrangement. **Well then, I will take this room,** he said. **Do you wish payment in advance?**

This is my rule, sir.

Here is your money for the first week.

Alessandro signed the rental agreement with a signature nowhere near as beautiful as his forefather's and then exchanged the money for the key. They shook hands and then the old fellow disappeared back down the dim staircase.

Alessandro stepped eagerly into what was now his new home.

Upon closer examination, he discovered that the bed had been made up with old but clean linen, the dresser contained soap, towels, and an extra blanket in the bottom drawer, and the green armchair was every bit as comfortable as it looked.

Inside the wardrobe he found not only an ample number of clothes hangers, but also a toaster, a coffee-maker, and a mini-fridge that had been thoughtfully stocked with a loaf of bread, a package of cheese slices, a chunk of salami, a tub of margarine, three apples, a can of coffee, and a six-pack of Pepsi.

After unpacking his suitcase, arranging his clothes in the wardrobe, setting a framed photograph of his parents on top of the dresser, and tucking the book into his pocket, Alessandro headed downstairs to the kitchen. It turned out to be a large room at the back of the house, well-equipped for

any kind of culinary endeavor. He thumbed through the book until he found the section called **The kitchen utensils.** He skimmed through the list. The stove. The poker. The pot. The lid. The boiler. The ladle. The grater. The coffee pot. The salt box. The stew pan. The sink. The sweepings. The ice box. The knife. The cleaver. The rack. The fryng pan.

He decided to make himself a stack of grilled cheese sandwiches which he figured would serve him well enough for supper tonight. Although there was no one else in the room just then, the elements of the stove were still warm and there was another frying pan soaking in the sink. He supposed he would meet some of his fellow residents in the next few days.

Back upstairs he started to study the book in earnest, reading aloud into the little room while reclining on the bed munching on his sandwiches, some salami, and then an apple. Whenever he stopped practicing his pronunciation (with extra work on that pesky *th* sound), he thought he could hear voices in the adjoining rooms, other young male voices also reciting and enunciating with exaggerated care.

I know *what* is good. I want to walk *which* is better than to ride. *Whoever* want a job must call. *Whatever* I do is wrong. *Whomsoever* eat that, must die. He looked at his half-eaten apple with alarm and tossed it into the wastebasket. He opened a bottle of Pepsi and continued.

The man *who* drinks. The food *that* I like. The car *which* run. The ladies *whom* inquire. The teacher *from whom* we learn. The boss *by whom* we are employed. The city *from which* we come. The wood *by which* we make chairs. The mother to *which* we are affectionated.

Yes, he should write to his mother right away to let her know he had arrived safely and was already settling into his new life. He gazed fondly at her photograph, at her warm dark eyes, her plump cheeks, her thin lips. In the picture she had her long dark hair tied back as always and she was wearing her long black dress with the white lace collar and the column of little pearl buttons…as always.

In the top dresser drawer he found a notepad, a pen, and a packet of pre-stamped airmail envelopes. He flipped ahead in the book until he found **Letter from a young man to his mother.** While copying this sample letter word for word, he thought he could hear the sound of other pens

scratching in the other rooms. But whenever he lifted his own pen from the paper, all he could hear was silence. He even went so far as to press his ear to the wall, but there was nothing save a soundless sense of breath being held and maybe the faintest muffle of a heartbeat. These emanations he assumed to be his own and continued writing out the letter.

> My darling mother:
>
> Here I am in a big city, surrounded by stranger and facing alone the problem of existence. I know exactly how you are worrying about me, mother dear, so hasten to tell you how my changed condition has affected me. I am neither depressed, frightened, nor dismayed. As yet I have not found my new life particularly arduous. I am sure you must sympathize with my happiness, dear mother, in spite of the fact that you are lonely without me. Give my fondest love to everybody at home, and with many kisses for yourself, believe me, ever your affectionate, grateful son.

Although there was no P.S. in the sample letter, Alessandro added a brief note thanking his mother for the book which, he said, was already proving extremely useful. And she would see from the return address on the envelope that he had followed his great-great-great's instructions and was already feeling comfortable at the rooming house he had noted inside the front cover. He would mail the letter in the morning.

He allowed himself to feel a little homesick but in what he felt was a cheerfully nostalgic and calmly mature manner. He missed everyone, of course, and he missed the smelly dog too. He drifted off to sleep while thinking fondly of everybody at home and studying the four-page list called **Man, his ages and relationship:**

Adolescence. Adoptive. Adulterine. Aunt. Baby boy. Baby girl. Bachelor. Bastard. Betrothed. Black (Nigger). Bride. Bridegroom. Brother. Children. Consanguinity. Cousin. Daughter. Decrepitude. Decease (Demise). Divorced. Elder. Father. Foudling. German. Great grand father. Great-grandmother. Illegittimate. Little boy. Little girl. Lover. Maidenhood. Manhood. Marriage. Marriageable. Maternity.

Minor. Miss. Mistress. Mother. Natural son. Only son. Sister. Sister-in-law. Son-in-law. Spinster. Step-daughter. Suckling baby. Sweetheart. Tutoress. Twins. Unborn. Uncle. Unmarried. Virgin (Maid). Vitality. White. Widow (Relict). Wives. Young gentleman.

Exhausted after his journey and all the details of arriving, Alessandro slept very well on his first night in the New World. He was not troubled by bad dreams, anxiety, jet lag, or the night-long noise of the traffic in the street three storeys below.

In the morning he awoke with the sun already streaming through the slats of the window blind, spilling in luminous stripes all across his body. He yawned and scratched and stretched luxuriously, congratulating himself on being a good young adventurer, adaptable and resilient, ready for anything the New World had to offer.

He took the book from the bedside table and flipped through the pages until he found the section called **Rising**. Of course he was alone, but he might as well practice while he had the chance.

Are you still in bed?
It is time to get up.
He is still asleep.
It is early yet.
It is after seven.
I did not know it was so late.
Please give me a piece of soap and a towel.

Yes, they were in the dresser. He paid a visit to the washroom at the end of the hall. As with the kitchen the previous evening, there was no one else in the room when he entered, but there was ample evidence of someone having just been and gone. A fog of shampoo-fragrant steam hovered near the ceiling lights and coated all the mirrors. There was a scattering of whiskers and a blob of toothpaste in the middle sink of the row of six. Several damp towels had been left hanging on a long bar to dry.

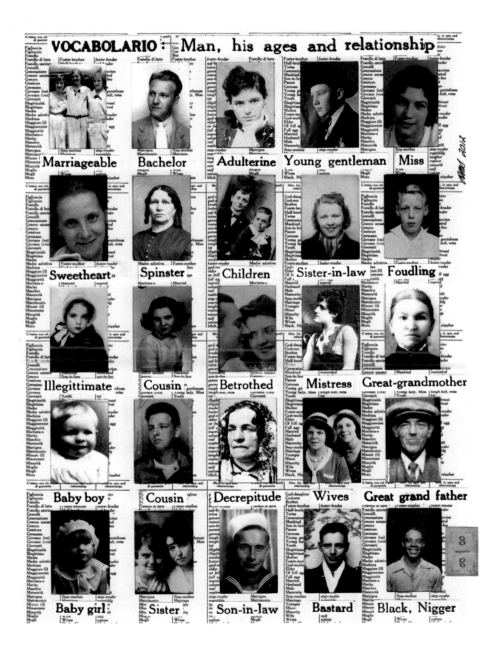

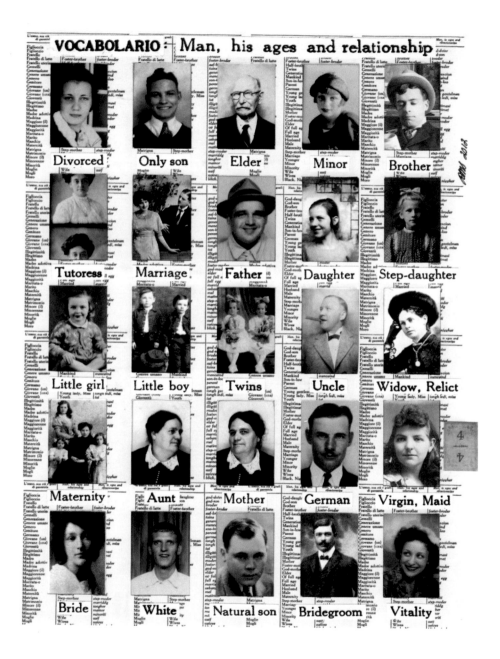

VOCABOLARIO — Man, his ages and relationship

Divorced

Only son

Elder

Minor

Brother

Tutoress

Marriage

Father

Daughter

Step-daughter

Little girl

Little boy

Twins

Uncle

Widow, Relict

Maternity

Aunt

Mother

German

Virgin, Maid

Bride

White

Natural son

Bridegroom

Vitality

On his way back to his room after his shower, Alessandro could smell bacon and possibly pancakes in the hallway. He was momentarily tempted to head down to the kitchen but, having never been one for a big breakfast, he went back to his room and made himself a pot of coffee and two pieces of toast.

Flipping through the book, he decided to copy out one more letter, this one called **Letter from a young man to his chum.** He addressed this one to his long-time friend Alfredo whom he had not seen or heard from for several weeks before he left.

Dear Old Man:

How goes the world with you?

Have heard nothing from you for so long that I am fearful of two things, one that you are in love and so, oblivious of everything and everybody but the object of your affections, the other that you have met with an accident which prevents you from writing letters.

I have no other news that I know would be likely to interest you, but you must have lots of things to tell me about yourself and all our old mutual friends from whom I am separated.

Hoping to hear from you soon, I remain yours as ever.

He chuckled to think how surprised Alfredo would be to receive a letter from the new Alessandro in the New World.

On his way out, Alessandro found the old fellow still at the front desk, checking his ledger with the giant magnifying glass, and looking as if he hadn't moved a single muscle since the day before. When Alessandro wished him a hearty good morning and asked for directions to the nearest market, the old fellow, pen in hand, waved impatiently toward the right and did not look up.

There was no one else around, but a suitcase much like Alessandro's own stood beside the desk.

Book in hand, he headed out the door and down the street to the right as the old fellow had indicated. There was a mailbox on the first corner he passed and he dropped the two letters into it. Four short blocks later he arrived at the market where it seemed that everything he could possibly want

was arranged in stalls under large white awnings that filled a whole city block. Making his way through the noisy crowd, he headed first to the grocer's stall.

What do you wish, sir? asked the grocer. A rotund man with a big bald head, rosy cheeks, and a jolly jiggling moustache, he looked just like a grocer should, just like a storybook grocer with his bountiful goods arrayed in colourful tiers all around him.

Alessandro was ready with the book open to the section called **With the grocer.**

I want two pounds of coffee. I also want half a pound of rice. Give me five cents of pepper. Give me a slice of gorgonzola. How much is a bag of salt? Give me two quarts of potatoes and eight cents of onions.

How much do I owe you?

Alessandro then went to the butcher's stall. Well over six feet tall with a heavy brow, glowering dark eyes, and (not surprisingly) blood smeared all over his white apron, the butcher could have stepped right out of the same storybook as the grocer.

Again, Alessandro made his purchases according to the book.

Give me a pound of kidneys. Have you any veal cutlets? I think they are too dear. Have you any fine beef? This meat is too fat. I want it thin. Give me some soup meat.

How much do you wish?

About two pound.

It is two pounds and a half.

Never mind. How much? I will pay you in full next week.

Alessandro thought the butcher might object to this, but it was in the book so he said it. The butcher nodded amiably enough, wrapped the meat in brown paper with an expert flourish, handed it over without comment, and turned quickly to the next customer.

Alessandro was not entirely sure what he was supposed to do with some of the ingredients he'd just bought. It seemed that maybe they would make a good hearty soup or stew. He had little cooking experience. Back home, his doting mother had always made sure he was well taken care of in the nourishment department. His own culinary repertoire did not extend much beyond

grilled cheese sandwiches, scrambled eggs, and the occasional hamburger. Too bad the book didn't include recipes. Maybe he would have to buy a cookbook.

Strolling back to the rooming house with his purchases in hand, it seemed to Alessandro that everywhere he turned, he saw people who looked somehow familiar. They were all smiling and nodding and tipping their hats to him. One elderly couple stopped for a chat in the sunshine.

Alessandro consulted the book for assistance.

Where are you going to? they asked, speaking, it seemed, as one person.

I am going home.

Where you come from?

I am coming from the market.

Where you went yesterday?

I went to see my sick neighbour.

Where will you go tomorrow?

To the theatre. Will you come with me?

We will not. We would go with you if we had time. Will you take a walk with us now?

No, you walk too fast.

In this case we must go without you.

Alessandro had always thought of himself as a polite and affable young man, but now, going by the book, many of the things he found himself saying struck him as downright rude. But nobody seemed to mind. It was confusing. Maybe it was all just part of becoming a New World man.

The couple shook his hand, wished him all the best, and continued on their way, not walking quickly at all. In fact, the white-haired old man was practically shuffling along with the blue-haired old woman clinging tightly to his arm.

Alessandro wondered about the sick neighbour they'd mentioned. He'd only just arrived. He didn't know any of his neighbours yet, sick or otherwise. Nor did he know anything much about the theatre.

As he watched the pair disappear around the next corner, Alessandro wished he'd asked the old woman how to make a good stew.

With the help of the book, Alessandro quickly discovered endless opportunities to practice his new language. He soon noticed that in the New World there was a lot more talk about time than there'd ever been back in the Old Country. Everyone here, it seemed, was always watching the clock.

What time is it?

Do you know what time it is?

Have you a watch with you?

It is early yet. It is not late yet. It is five o'clock. It is ten minutes past five. It is a quarter past five. It is twenty minutes after five. It is half past five. It is a quarter to six. It is five minutes to six. Has it striken six? There it strikes now. Do you hear?

What time is it by your watch?

It is just eleven o'clock.

Your watch is too fast.

No, it is four minutes too slow.

What time is it by the town clock?

It is exactly thirteen minutes past twelve.

My watch stopped. I must wind it up. Have you a watch key about you? I had no idea that it was so late.

There was also the weather which, self-evident though it tended to be, seemed to require frequent, detailed, and repetitive comments of both commendation and complaint by each and every person he encountered in his ramblings around the neighbourhood.

How is the weather? It is very fine weather. It is splendid weather. It is neither too cold nor too warm. The sky is clear. The sun shines. The weather could not be finer. We shall have a fine day. It is too fine to last long. The wind blows from the North. The weather will change soon.

Alessandro chuckled at this New World cynicism. But sure enough, a few minutes later he was soaked to the skin in a sudden downpour. He could have sworn there hadn't been a cloud in the sky.

See how it rains! It rains very hard. It pours. Can you lend me an umbrella? The clouds are as black as night. It begins to hail. It thunders and lightens. It will soon clear up. The storm is over. The

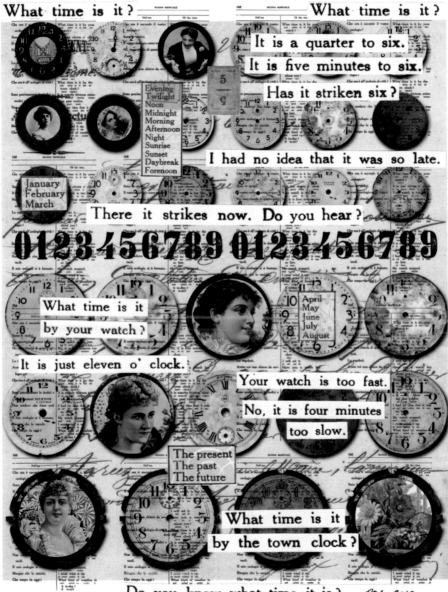

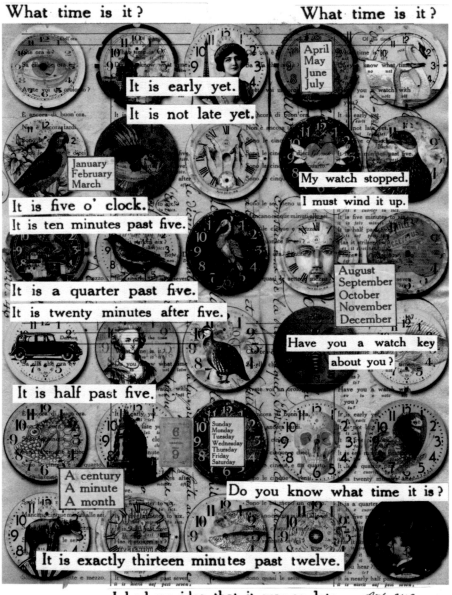

What time is it? What time is it?

It is early yet.

It is not late yet.

April May June July

January February March

My watch stopped.

I must wind it up.

It is five o' clock.

It is ten minutes past five.

It is a quarter past five.

It is twenty minutes after five.

August September October November December

Have you a watch key about you?

It is half past five.

Sunday Monday Tuesday Wednesday Thursday Friday Saturday

A century A minute A month

Do you know what time it is?

It is exactly thirteen minutes past twelve.

I had no idea that it was so late. *AMS 2012*

sun begins to shine again. Do you see the rainbow? We shall have a pleasant evening.

Yes, there it was: a luminous double rainbow arching across the western sky.

Book in hand, Alessandro rehearsed for the changing seasons well in advance.

It is warm. It is very warm. It is sultry. It is close. It is very dusty. It is cloudy. It is a beautiful night. The days are getting shorter. It is cool. It is foggy. What a heavy fog!

The nights are already very cold. Winter is coming on. It freezes. It will freeze tonight. It has frozen last night. How it snows! I shiver with cold.

Let us skate.

I have no skates.

Alessandro wondered if he should buy a pair of skates (as well as an umbrella and a cookbook).

The snow melts. It begins to thaw. The air is getting milder. It will soon be spring.

The sun rises. The sun sets.

Indeed. Some things, it seemed, were universal.

Alone in his room, Alessandro devoted many hours to studying the book. In the section called **Sicknesses**, he learned a number of words and phrases that would no doubt prove useful should his youthful good health ever fail him.

Palpitation. Dizziness. Constipation. Bellyache. Hemorrhage. Piles. Infection. Leprosy. Lumbago. Pimple on the eyelid. Madness. Frenzy. Rotteness. Gout. Consumption. Cholera. Scurvy. Pustule. Rickets. Bile. Mange. Grave yard cough. Hooping cough. Swolled vein. Belching. Ringworm. Tootake. Dropsy. Corns. Scrofula. Erysipelas. Quinsy.

The book also offered dialogues with the doctor he might have to see some day.

Good morning, doctor.

How do you feel?

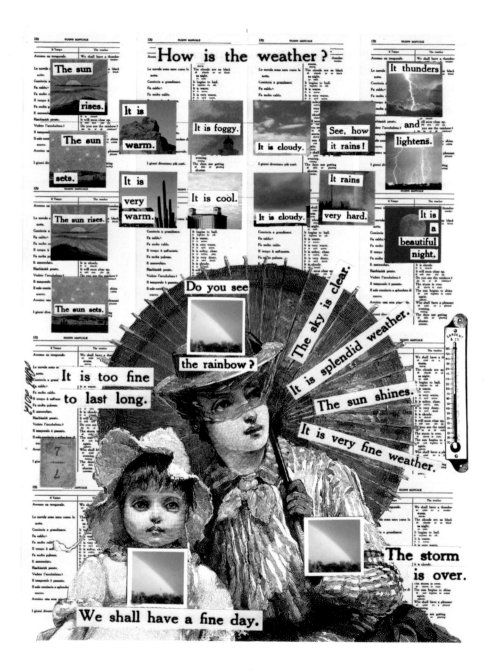

How is the weather?

The sun rises.

The sun sets.

It is warm.

It is very warm.

It is foggy.

It is cool.

It is cloudy.

It is cloudy.

See, how it rains!

It rains very hard.

It thunders

and lightens.

It is a beautiful night.

The sun rises.

The sun sets.

Do you see the rainbow?

The sky is clear.

It is splendid weather.

The sun shines.

It is very fine weather.

It is too fine to last long.

We shall have a fine day.

The storm is over.

I am not quite well.

What ails you? Did you vomit during the night? Did you take medicine?

I have taken some pills.

Let me feel your pulse. Have you eaten anything since? Do you feel very thirsty? Do you cough? Show me your tongue.

Doctor, may I get up today?

No, you cannot get up. In two weeks from now you will be able to go out again.

In the lengthy section called **The Uman Body**, he learned a number of words that he was not likely ever to say out loud to anyone, words that made him blush even in the solitude of his little room.

Anus. Groin. Nipple. Teat. Clitoris. Hymen. Cervix. Penis. Prepuce. Scrotum. Sperm. Testicle. Vagina. Vulva. Syphilis. Impotency. Clap.

He turned to more innocuous, less embarrassing sections and eventually fell asleep with the book still in his hand. In the morning he was amazed to discover that he could remember every single word and phrase he'd studied the night before.

One night it was a long list of regular verbs:

To bake. To bear. To beat. To bite. To bleed. To blend. To blow. To break. To breed. To build. To burn. To burst. To catch. To cling. To creep. To crow. To cut. To dare. To dream. To drink. To drive. To fall. To feel. To fight. To grind. To grow. To hang. To hide. To hit. To hold. To hurt. To knit. To know. To leap. To lie. To lose. To meet. To mow. To pay. To pen. To quit. To rid. To ride. To ring. To saw. To seek. To shake. To shine. To shoot. To shut. To slink. To smite. To steal. To sting. To stink. To swell. To swim. To teach. To tell. To thrive. To thrust. To wax. To weep. To work. To wring. To write. To writhe.

The next night it was a list of animals, birds, fishes, and insects.

Lamb. Donkey. Puppy. Bitch. Setter. Kitten. Pussy. Tomcat. Horse. Hog. Goat. Porcupine. Weasel. Wild beast. Camel. Elephant. Leopard. Lion. Tiger. Hippopotamus. Monkey. Bird of passage. Bird of prey. Vulture. Titmouse. Humming bird. Pheasant. Snipe. Stork. Bat. Eel.

Fish. Sea fish. Anchovy. Herring. Leech. Mackerel. Carp. Whale. Shark. Seal. Toad. Frog. Maggot. Snail. Spider. Fly. Flea. Cockroach. Grasshopper. Moth. Butterfly. Earthworm. Glowworm. Blindworm. Tapeworm. Snake.

Swans are an ornament to lakes and rivers.

Alessandro wasn't sure when or where he would ever have occasion to use many of these but still, they were certainly worth knowing.

Over his morning coffee and toast, he read through the section called **Commerce, industries, arts, trades, etc.** Here it was evident that the New World was indeed, as promised, the quintessential land of unparalleled and unbounded opportunity. The list of possible occupations filled ten whole pages! Having only ever worked as a clerk in the family business, he'd had no idea there were so many different things to do in the world!

Piano-tuner. Rope-dancer. Silver-smith. Gunsmith. Fakir. Scissors grinder. Artist. Undertaker. Astronomer. Author. Bookbinder. Midwife. Wet-nurse. Grave-digger. Gold-beater. Botanist. Button maker. Tinker. Chiropodist. Jailer. Engraver. Clairvoyant. Furrier. Surgeon. Cobbler. Bicyclist. Comedian. Jockey. Monk. Inventor. Lackey. Lapidary. Fencing-master. Oculist. Organ-grinder. Oyster-man. Sexton. Sausage-maker. Shirt-maker. Shoe-maker. Sieve-maker. Soap-maker. Lantern-maker. Looking-glass-maker. Pin-maker. Bird-cage maker. Mattress-maker. Bonnet-maker. Ice-cream maker. Violinist. Wine merchant. Cow-keeper.

Man of all work.

Certainly it was time to think about looking for a job. The money he'd brought with him, money he's been secretly saving for years, was plenty to survive on for now but he knew it wouldn't last forever. He studied the **Looking for work** section in the book that outlined the dialogue for a visit to the employment agency.

Can you give me any work?
Can you speak English?
Very little.
You must learn it. Do you expect high wages?

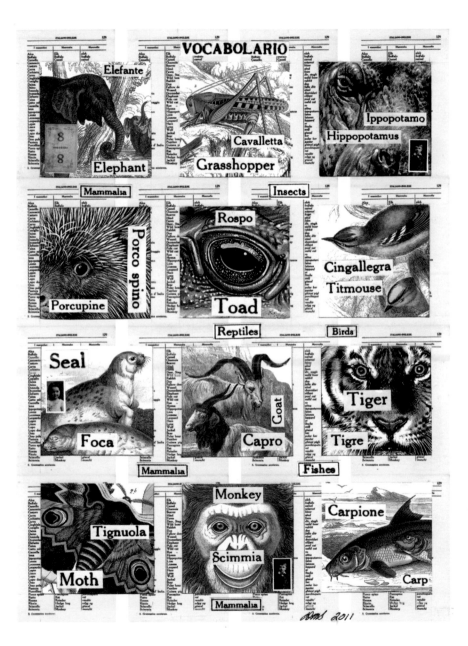

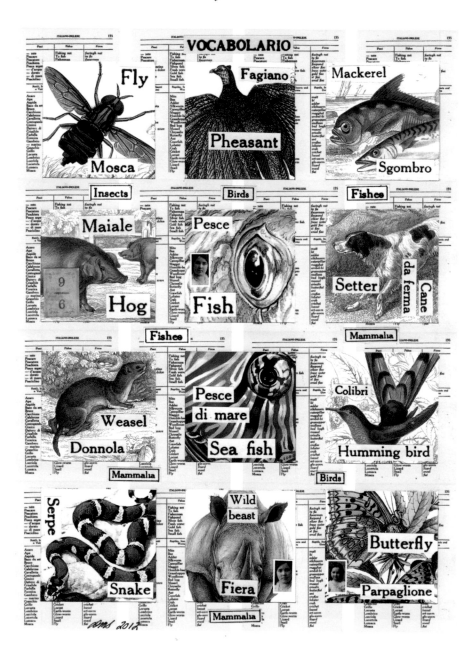

Not very. I would be satisfied with only a hundred dollars a month.
What kind of work you look for?

I have no trade. But I am ready to do any hard work.

Wanted three hundred hands for a coal mine. Twenty hands wanted for a shoe factory. Do you know how to sole boots well? Do you know how to patch and mend? Do you understand cutting? Can you sew on the machine? Are you a forniture maker? Do you understand cooking well? Can you take care of children? Can you plough? Can you mow? Can you manage horses? Can you milk cows?

I cannot milk cows.

Alessandro had to admit he knew nothing about cows, coal, cooking, children, horses, sewing, or boots. He figured that even here in the New World, he'd be better off sticking to what he knew.

Have you a situation for a clerk?

Such situations are very scarce. You can't get such a situation here. Try some other kind of employment.

It did not seem that a visit to the employment agency was likely to be very fruitful. So Alessandro decided to take a different approach in his job search. He began reading the classified ads in the newspaper every morning. With the help of the book he sent letters and his resumé to every company that looked even remotely promising.

Dear Sir,

In answer to your advertisement in this morning Sun I beg to make the application for the same. I am confident to be able to fill the position in a manner thoroughly satisfactory to you. I am twenty-five years of age, willing, obliging, sober and of good moral character. For any further explanation you may need, I will be glad to give the same personally, at any time you may wish. In the meantime I refer you to the following firm with whom you can communicate for information as to my ability and integrity. Hoping to receive a favorable reply, I remain,

Yours respectfully.

The firm to which he directed prospective employers for references was, of course, the family business back in the Old Country. He had never worked anywhere else. The ads for general clerks and assistant clerks and associate clerks and junior clerks and senior clerks to which he responded all described jobs that sounded quite similar to what he'd done before. At the family business his days had been filled with paperwork. His duties had consisted primarily of placing orders, taking inventory, and writing letters, letters, lots of letters.

Now he waited and waited for replies to his letters of inquiry, sometimes patiently, sometimes impatiently. He tried to remain confident that he would indeed soon be hired somewhere. In the meantime, in order to be fully prepared when he did get a job, he studied the section of the book called **Modern Commercial Letters.** He repeatedly copied out the letters that might be useful when the time came.

Dear Sirs,

Please ship us immediately by freight the goods as per enclosed invoice. Of the full amount for your bill you will charge our account.

10 Cases Sardines in tin boxes	100 Pounds Roman Cheese
10 Cases Anchovies in tin boxes	100 Boxes Macaroni Assorted
20 Cases Olive Oil	10 Barrels Flower
50 Bags Rice	4 Cases Vermouth
50 Boxes Peas in cans	1 Barrel Whiskey.

If the goods received were not up to the exacting standards of his employer, it was the clerk's responsibility to deal with the problem. In these cases, according to the book, the clerk was apparently allowed to be more than a little puffed up with his own indignation and so should fire off a firm reply with great gusto.

Dear Sirs,

With this present I call your attention to the fact, that the goods shipped by you has reached me today in very bad condition. Furthermore

the rice is not of the first quality, the macaroni is not assorted as it should have been, and the cheese is almost rotten. The oil is quite inferior for quality. Therefore I have refused the whole shipment.

The reply to this was also included in the book.

Sir,

 We are very sorry to learn that you have refused the whole shipment. Of your complain, the only reasonable one is that regarding the olive oil and the cheese; our shipping clerk has made a mistake about these goods. The balance of your order was filled strictly according to your instruction, and we don't see how you can complain.

Alessandro laughed out loud. The nerve of some people! He began composing another pointed missive in his head, as the book did not give a reply to this reply.

Despite the intermittent aggravation and the endless paperwork, Alessandro had always been happy in his work in the Old Country. He assumed that he would be again once he found the right employer here in the New World. He would not despair. Ever the optimist, he was disappointed, but not unduly discouraged, by the lack of responses to his letters. Surely something would turn up eventually.

In the meantime, he figured he should at least look the part. Here in the New World, his Old Country clothes looked just that: old and countrified.

He discovered a menswear shop just two streets over. Inside, he found many racks of clothing, no other customers, and one very eager salesman. He was waited on immediately by this immaculately dressed young man. He had not even had time to look around, had barely managed to find the right page in the book.

Can I help you, sir?

I want a full suit for every day wear. But it must not cost too much.

The salesman darted around the small store, spinning through several racks and then returning to Alessandro with a pale grey suit in hand.

Here is one.

I don't like the color. I should like to have a darker one.

The salesman obliged and returned with a dark grey suit.

Is the price the same? Alessandro asked. **Can I try it on?**

Certainly; over there is the dressing room.

Once inside the tiny mirrored room, Alessandro shrugged out of his Old Country clothes and squirmed into the stylish New World suit. He tried not to think about claustrophobia. He emerged to find the salesman waiting, smiling expectantly. They stood together and admired the suit in yet another mirror.

The vest seems to be rather short, said Alessandro, tugging at it.

No sir, it is long enough, the salesman assured him confidently.

Not being up to date on fashion and current styles in the New World (or otherwise), Alessandro was happy enough to take his word for it.

Well then, I think I will take this suit, he said. **Here is the money.**

Alessandro then went to the shoe store directly across the street. Again, there appeared to be no other customers and he was quickly taken care of by a smartly dressed young man whose hair and shoes (of course) were perfect.

I want a pair of new shoes. The book, it seemed, was keen on stating the obvious.

The salesman showed Alessandro to a chair with a floor-level mirror in front of it and pulled a box from a nearby shelf.

Will you try on this pair? he asked, opening the box with a magician's flourish to display a pair of elegant black laced oxford brogues. Alessandro was sure they were the nicest shoes he'd ever seen in his life. But when he tried them on, he was disappointed to discover they were too small.

They are too tight; they hurt me, he said sadly. But the salesman did not seem at all worried and he bustled around in the stacks of boxes behind him.

Offering Alessandro another box with a flourish, he said, **Here is another pair that will no doubt fit you.** They were identical to the first pair, one size larger.

They are just a little too large, Alessandro said, **but I think I shall keep them. How much do you ask for these shoes? Here is your money.**

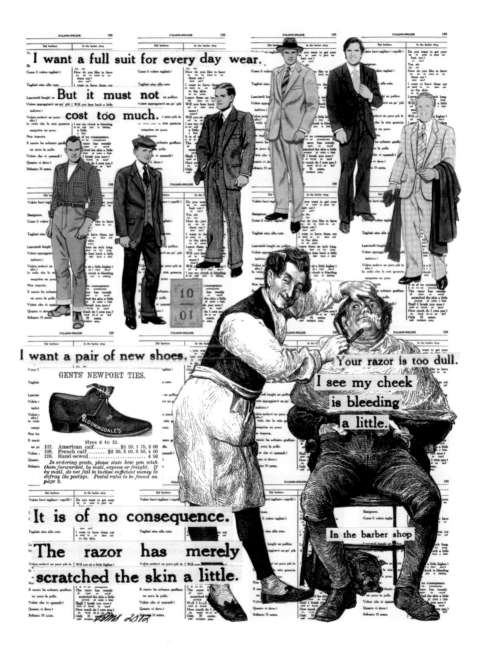

I want a full suit for every day wear.

But it must not cost too much.

I want a pair of new shoes.

GENTS' NEWPORT TIES.

BLOOMINGDALE'S

Sizes 6 to 12.
117. American calf.................$1 50, 1 75, 2 00
118. French calf.................$2 50, 3 00, 3 50, 4 00
119. Hand-sewed......................... 4 50
 In ordering goods, please state how you wish them forwarded, by mail, express or freight. If by mail, do not fail to inclose sufficient money to defray the postage. Postal rates to be found on page 2.

It is of no consequence.

The razor has merely scratched the skin a little.

Your razor is too dull.

I see my cheek is bleeding a little.

In the barber shop

After ringing up the sale and giving Alessandro his change, the salesman asked, **Shall I wrap up the new shoes for you?**

No, I will keep them on and leave the old ones here.

With his old shoes thus summarily abandoned, his new shoes on his feet, and his new suit in a bundle under his arm, Alessandro went into the barbershop next door.

Do you want to get your hair cut? asked the barber, a middle-aged man with bushy eyebrows, a double chin, and a slightly shaky hand. **How do you like to have them cut? Do you want to have them cut to the skin?**

No, leave them an inch long.

The barber set to work. **Will you lean back a little more? Will you sit a little higher? Shall I part you hair in the middle? Shall I brush you now? Will you look yourself in the glass?** Alessandro briefly admired himself in the hand mirror the barber held out to him.

I wish also to get a shave. I have very tender skin.

Again, the barber set to work.

Your razor is too dull, Alessandro soon complained. **I see my cheek is bleeding a little.**

It is of no consequence, said the barber with a nasty laugh. **The razor has merely scratched the skin a little.**

Obviously Alessandro would be wise to find another barber next time around, one with a steadier hand and a less cavalier attitude about drawing blood. Maybe he could ask the old fellow at the front desk of the rooming house for a recommendation. But it seemed that, since that first friendly conversation when he'd rented the room, the old fellow had been rendered mute, seldom looking up from his eternal perusal of his enormous ledger, answering all inquiries only with shrugs, gestures, and impatient sighs. It was as if, having helped Alessandro to get settled, he now wanted nothing more to do with him.

Back at the rooming house, Alessandro nodded to the old fellow but said nothing. The old fellow, true to form, did not look up or speak.

Upstairs Alessandro put on his new outfit and admired himself in the full-length mirror in the bathroom. Yes, he was indeed a fine figure of a

New World man, well-dressed, well-shod, and well-groomed. This was a moment when the words *chiselled, patrician,* and *intelligent* did indeed flit through his mind. (And surely that cut on his cheek would heal up quickly enough).

Yes, now he was ready. Ready for anything.

Now Alessandro was ready to find himself a good wife. Much as there were several young women back in the Old Country of whom he'd been quite fond, not a single one of them had truly made his heart sing. They were good girls, all of them, many he'd known since childhood and maybe that was half the problem. They were more like sisters, a few more like mothers. They had all professed to love him (some profusely, tearfully, relentlessly) but he, in all honesty, could not say the same. They were not like lovers at all. In fact, he could not bring himself to say the word *lover* aloud when thinking of any of them. He had to admit he was looking for someone smarter, sleeker, sexier. He had to admit he was looking for a New World woman who would be the ideal complement to his reinvention of himself as a New World man.

The book, not surprisingly, was quite promising in this regard. It gave him every reason to believe that he would indeed find her here: the woman of his dreams. For starters, it contained five whole pages of the conjugation of the regular verb **to love.**

I shall love. She will love. We shall love. You will love. They shall love. I should love. She would love. We should love. You would love. We should have loved. We might have loved. You may have loved.

Do I love? Does she love? Do we love? Do you love? Did she love? Did they love?

Let us love!

There was also a thirty-page section called **Love Letters.** How could he possibly go wrong? Having tended to the practical matters of life in the New World, Alessandro was ready now to turn his attention to the sublime. He already had someone in mind.

There was an attractive young woman he watched every evening as she walked her little white dog past the rooming house. The sight of her little dog gave him a pang of missing his own smelly dog, Suzy. Sitting in his armchair by the window, he could admire her secretly from his third-floor perch. He especially liked the look of her curly long blonde hair lifted gently by the breeze, her round calves plumped up by the high heels in which she so gracefully navigated the uneven sidewalk, the stirring and worship-worthy shape of her behind as she walked away from him. Lovingly familiar though he had become with the endearing sight of the top of her head, he couldn't see her face clearly from his bird's-eye view vantage point. But he was sure she was beautiful. And intelligent too. And obviously she too was a dog-lover. Already they had so much in common! On rainy evenings when she did not appear, he was bereft.

One evening he followed her (discreetly, of course) and discovered that she lived in a building just around the corner. He ran back to his room, grabbed the book, and turned to the letter called **To a lady entirely unknown**. He noticed that his great-great-great-grandfather had marked it with three exclamation points in the margin. He transcribed the letter word for word in his very best handwriting.

> **Miss:**
>
> I am at a loss as to how I shall address a lady unknown to me. My first duty is to apologize for writing this letter. I know that only by some fortunate circumstance I may be introduced to you, but that I have not! I am irresistibly impelled by the deep impression which you have made upon me. For several weeks I have seen you passing by and every time I have gazed upon you, have been more intensely desirous of seeing you again. At first I have seen you gladly; after I have longed for the minute I could see you pass, and now I am at your mercy!
>
> Please allow this letter to commence a friendship which, no doubt, will make me more happy than I can say, and trusting to receive a few lines from you I am,
>
> Yours very sincerely, Alessandro.

He put this missive immediately into an envelope marked with his return address, licked the flap with hope and longing, hurried back to her building, and slipped it in the mailbox. That night he couldn't sleep for wondering what would happen next.

The book provided the young woman with two alternate replies. Of course, Alessandro was hoping she would select the second option:

Mr. Alessandro:

Your kind letter reached me at this moment, and I am not sure that I should answer it at all, and certainly I should not. Yet by the meaning of your words I am certain I am corresponding with a gentleman, who will never take advantage of an innocent girl. If the friendship you desire, can make you happy I will the same.

More than this I cannot need to say, and will only add that I am,

Yours sincerely,

Miss Louisa C.

Oh, my lovely Louisa! Alessandro cried. He lay awake all night imagining her arms, her charms, the grand house they would live in someday, the cherubic children they would have, and the little white dog they would henceforth walk together through the city streets.

Early the next morning an envelope was slipped under his door. He leapt out of bed and scooped it up.

Sadly she had chosen the first option instead.

Sir:

I am very reluctant to reply to your letter, I only do so in order that you may not have the least pretext for mistaking my feeling on the subject. For no reason will I permit you to write me again, and any insistance on your part, will be considered as an affront and an affront will be your letter.

Miss Louisa C.

Alas, alas, my lovely Louisa! Alessandro cried. Heart broken, hopes dashed, he spent the rest of the day in bed.

In fact, he never saw his lovely Louisa again. Either she had moved away to avoid him or she had decided to do her dog-walking elsewhere.

Romantically resilient as young men tend to be, Alessandro recovered quickly enough from this first experience of rejection. He decided that, in order to meet his perfect future New World wife, he would have to get out more.

One afternoon while paying yet another visit to the grocer and the butcher, he stopped to read a tattered notice tacked to a hydro pole. It was a poster announcing Saturday night singles dances at the neighbourhood community centre.

He went that very weekend, feeling handsome and adventurous in his new suit and shoes. The cavernous hall was already filled with young men and women when he arrived. The music was loud and the dancing was in full swing.

Alessandro supposed that some of these dancing young men might well be fellow residents of his rooming house. But much as he saw evidence of their presence every day (dirty dishes and cooking odours in the kitchen, wet towels and empty shampoo bottles in the bathroom, a pair of muddy work boots left in the stairwell, a jacket draped over a chair in the lobby), still he had not yet met a single one of them. It was as if they were ghosts. He would hear footsteps in the hallway but when he opened his door there was no one there: just a slight fragrance of shaving lotion or a disturbance in the air of a person having just passed through it or a glimpse of a coat-tail rounding the corner at the end of the hall. He had even gone so far as to knock on the doors of a few other rooms on his floor but nobody ever answered.

But tonight at the dance he was not interested in meeting his mysterious fellow residents. Tonight at the dance he was only interested in meeting a woman.

He was not disappointed.

There were dozens of young women there, all of them smiling with perfect teeth and fragrant with delicious perfumes, many of them eager to introduce themselves, shaking his hand vigorously or patting his arm in a slightly more-than-friendly fashion. He was overwhelmed at first and their names swam in his head: Clotilde, Annie, Olga, Emily, Nina, Silvia, Teresa, Angela, Lucia, Camilla, Louise, and more, so many more.

By the end of the evening he was happily exhausted from dancing and laughing and chatting, and there was one woman who stood out the most in his mind. The next morning, he copied out another letter.

Miss Clotilde:

One of the most beautiful evenings I ever spent in my life, was last night at the ball, when I had the pleasure of making your acquaintance. I have never before felt such delight, and certainly it must be due to your very kind manner and grace. The time never seemed so short to me, and actually I have regretted the parting from you. Pardon me if I take the liberty in saying so much as this, but I feel unable to restrain the sincerity of my feelings. If you will allow me to become a more close friend, I shall regard myself as most fortunate and happy, and I will not disguise from you, that I await with great eagerness the favor of a kind word.

At the dance she'd happened to mention where she lived. Coincidentally it was in the same building as his lovely (but now lost) Louisa. Again he dropped his missive into the mailbox, went back to his room, and waited.

Oh my comely Clotilde! he exclaimed repeatedly as he remembered the lustre of her golden hair, the curve of her slender waist, the come-hither laughter tumbling from her ruby lips. Not an hour later an envelope was slipped under his door. He tore it open with trembling fingers.

Mr. Alessandro:

I have received your letter and in answer I beg to state, that the contents surprises me very much. I am not aware that the mere fact of an introduction, and subsequently becoming partners in one or two dances,

and spending a few hours of social conversation, is any reason why you should suppose me willing to receive your letter, or your declaration. Had I thought that by reciprocating your desire that the evening should pass pleasantly, I should subject myself to what must certainly be thought, a liberty, I should have acted in a different manner. As passing acquaintances we may meet again, but in no other way can we do so.

Alas, alas, my comely Clotilde! cried Alessandro. Another disappointment was more than he could bear. Both his heart and his ego were badly bruised. He wept into his pillow all afternoon like a girl.

Clearly these New World women were a lot harder to snag than he'd expected.

What, oh what, was he doing wrong?

In an attempt to recover from this second heartbreak, Alessandro avoided the Saturday night dance for a couple of weeks. During that time he heard from his mother that his recently betrothed cousin Maria had indeed been married to her beloved Roberto. Reading over all the glorious details of the wedding as his mother had described them and looking at the photograph of the happy couple she had enclosed, Alessandro could not help but feel even sorrier for himself. After wallowing in his misery for a few days, he began to feel a little better, well enough at least to do the right thing and send Roberto a letter of congratulation. He hoped they had by now forgiven him for taking the wind out of their sails at their engagement dinner when he had announced his plan to emigrate to the New World. Straight from the book he copied the letter called **To a person who has got married.**

Dear Roberto:

I hasten to express to you the pleasure which the news of your happy marriage has caused me. Heaven grant you and your dear wife Maria a long series of happy years. I hope you may have a large family, which will

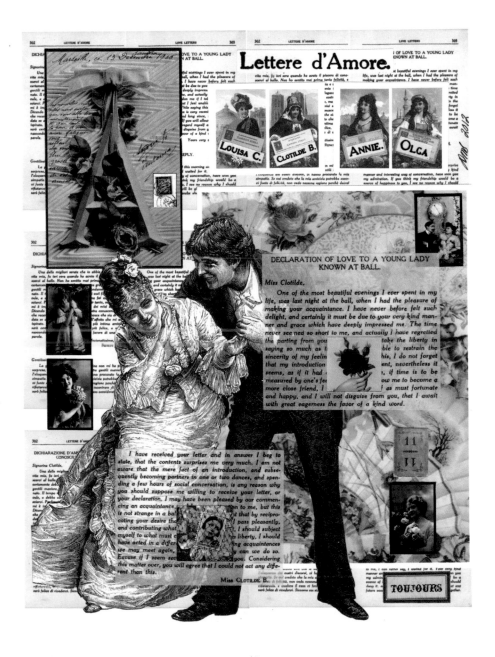

increase the number of good people. Because sons brought up under your own eyes and stimulated by your good example cannot fail to resemble you.

Yours affectionately,

Alessandro.

As the days went by, Alessandro's depression began to lift and soon he felt ready to try again. Maybe he'd been too forward. Maybe his eagerness had smacked of desperation. Maybe he should take his time and play at least a *little* hard to get.

That very night he danced with a voluptuous redhead named Irma who had not been there last time. She said that she too was new in town. (Having now been summarily dismissed by two blondes in a row, he was branching out and turning his attention to other hair colours.) This time, after the dance, he did not go home and write her a letter immediately as he had with his lovely Louisa. Nor did he write her a letter the very next morning as he had with his comely Clotilde. This time he waited impatiently for the following Saturday night and danced with her again, several times. She grew increasingly flirtatious as the evening went on. But again, he did not go home and write her a letter. He waited out another week.

This time when he arrived at the community centre (fashionably late!) she rushed across the room and kissed him. She was wearing a form-fitting low-cut white dress. He could practically see her breasts! She leaned forward and pressed herself against him for a moment. She was practically purring!

Now this was more like it!

That night he *did* write her a letter immediately after the dance, one called **Ardent Love**, and he delivered it directly to the address she had so boldly given him. Thank God she didn't live in the same building as his lovely (but lost) Louisa and his comely (but cranky) Clotilde.

Irma:

I saw you at the ball last evening. You looked nice in your white costume! You were fascinating. I followed you with my eyes wherever you went! I have you ever in my mind! Irma, if you only knew how tenderly

I love, and call your name! Irma, I adore you, don't make me unhappy. You are noble, good and generous, and would not have me suffer! You have clasped my hand, and looked into my eyes and kissed me, and how I would love to kiss you again. My head is in a whirl, I think of, and see you, I call you, but you are too far, too far away, Irma! When will I see you again?

Oh my inimitable illustrious iridescent Irma! he cried, after looking up the adjectives in the book. Although it was three in the morning, he barely had time to begin indulging his fantasies when a bright pink envelope appeared under his door. He clutched it to his nose: it was perfumed! The notepaper inside was decorated with hearts and cherubs.

Alessandro:
 I must and want to see you again, and not later than tomorrow evening. My dear Alessandro, tell no one of this, please; I will be at the corner of your street at 7 o'clock sharp. More kisses shall bind our promise of love forever, and until, tomorrow evening I bid you good bye, my darling.
 Yours for life, Irma!

Alessandro was faint with joy.

📖

And so it began.
 Like most young lovers, Alessandro and Irma couldn't get enough of each other. They were so in love that their exuberant happiness spread like a sparkling shower over everyone they met. Most of the time they could hardly believe their good luck in having found each other. They spent as much time together as they possibly could and felt mournful and unsettled when apart. They wondered how they had ever managed to survive without each other. They agreed that every single day of their formerly separate lives had been long and lonely, unfulfilling and uninteresting. They shuddered

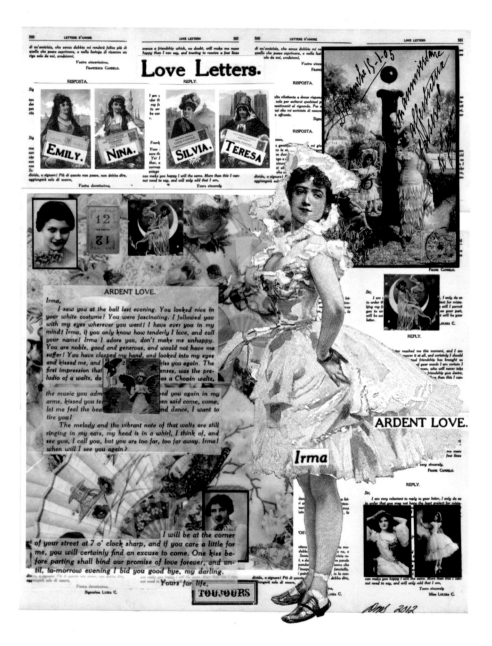

to think how miserable they each would have continued to be had fate not so happily intervened and finally brought them together.

But, like all relationships, theirs was not without its melodrama, its misunderstandings, its moods, and its most aggravating ups and downs. Thankfully these problems too were covered by the book.

Irma's boldly flirtatious nature was not always confined to Alessandro alone and, after one especially distressing evening, he was so upset that he didn't have the nerve to speak to her in person so he copied out a letter called **Jealousy and Inconstancy.**

Irma:

You cannot but be aware that I have just reason for saying that you have displeased me. You cannot suppose that I can quietly see you disregard my feelings, and step upon my affection and love. When the other evening I requested you not to be so expansive, neither accept so many compliments by a certain party, you have done contrary to my wishes, and perhaps did not care whether I was pleased or not. Your manner toward this other man is entirely too free, and if your affection for me is pure and sincere, it would be part of your ambition to avoid certain occasions that bring me any displeasure. If a new friendship, and a word of a stranger, can impress you so much, it is just to say that you could easily love him too!

I write to you more in sorrow than in anger, and I trust you will reassure me of your affection, if you care for my love.

She made him wait for two days before she replied.

Alessandro:

Are you not a little unkind? Jealousy is a bad adviser and you do injustice to yourself in thinking that I could be of such a light mind and so changeable. You have mistaken a few harmless gaiety for levity on my part, and I am very sorry that you have done so. My love for you is my Faith! and I am sure you will forgive an indiscretion on my part, for it was

nothing more. Write me soon and tell me that you were wrong, or I will not like you any more, bad boy!

Your loving, Irma!

The very next night, after an especially amorous rendezvous to reinforce their reconciliation, Alessandro received an urgent message from his mother. He must return at once, she begged, his father was very ill. Although it was certain that he would recover eventually, still Alessandro was desperately needed to keep the family business afloat until such time as his dear father was, literally, back on his feet.

With barely time to pack his clothes and book a ticket, Alessandro was relieved to discover that the book covered this unpleasant eventuality as well. He scribbled out the anguished letter called **To the Sweetheart Before Parting**.

My dearest dear Irma:

I am compelled to undertake a long journey, and I shall be far distant from you. I have learned to love you so dearly, that this departure is to me a great torture. I must speak plainly upon the love which I have so long borne toward you. I cannot command to my heart, I have been always sincere and loyal to my affections and before parting I would like to be sure of your love for me. If I can carry with me, the assurance of your affection, and the hope of its fulfillment, I shall be happy indeed. Your answer shall decide for my future.

Believe one that loves you dearest, your Alessandro.

In the darkness, he ran to her building and dropped the letter in her mailbox. He had no time to linger and ran directly back to the rooming house where his suitcase waited in the lobby.

Moments before he was to leave, Irma rushed into the lobby, barefoot and wearing only her see-through black negligée. Even the old fellow at the front desk reacted to this. He looked up from the ledger, rolled his eyes, and smirked. Weeping wildly, Irma covered Alessandro's face with wet kisses and pressed an envelope into his hand.

Then she was gone.

For Alessandro the interminable flight back to the Old Country was made bearable only by reading and rereading her letter a thousand times.

> Dearling Alessandro:
>
> How much I suffer, how unfortunate I am! Why must you go away? My future is left in your hands, I love you sincerely, I live only for you! How sad it is to be so affectionate and forced by circumstances to be separated thousands of miles from the object of your affection. But you will return and then forever be mine! We must humbly resing ourselves to the dispensation of the Almighty will, and believe that everything is ordered for the best. That He who notes the fall of a feather from a bird's wing, may watch over you, and protect you from all evil.
>
> This is my prayer, the only prayer of your very affectionate Irma.

Alessandro's parents were so happy to have him home again that he could hardly begrudge them their joy. He did not say anything to them about Irma as he felt he was too old and mature now to be crying on his mother's shoulder, but he missed her miserably. Keeping busy helped, so he applied himself ever more diligently to the management of the family business. His father did not seem quite so desperately ill as his mother had implied. But he was not about to accuse her of exaggerating his illness in a manipulative attempt to get her baby boy back. He could not bring himself to think badly of her.

When he ran out of work tasks to keep himself occupied, he took long rambling walks with his stinky dog, Suzy, and told her all about Irma, the love of his life. Suzy, of course, was so deliriously happy to have her young master home again that she would listen to anything he said, even when he said the same things over and over again, even when he ended up crying against her soft yellow ears.

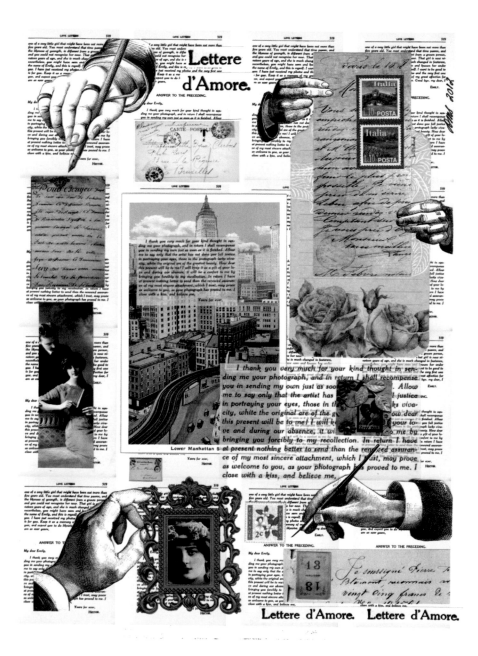

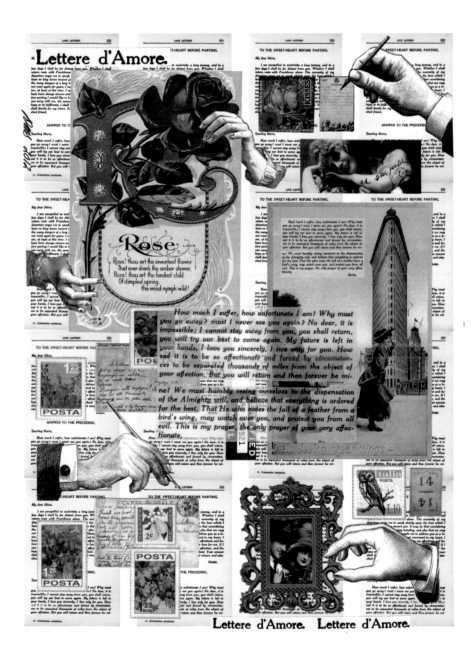

He wrote to Irma every other day and she wrote back almost as often. She sent him a very fetching photograph of herself in which her dark eyes sparkled and her dewy cleavage winked.

My dear Irma: he wrote in reply.

> I thank you very much for your kind thought in sending me your photograph, and in return I shall recompense you in sending my own just as soon as it is finished. Allow me to say only that the artist has not done you full justice in portraying your eyes, those in the photograph lacks vivacity, while the original are of the greatest beauty. How dear this present will be to me! I will keep it as a gift of your love and during our absence, it will be a comfort to me by bringing you forcibly to my recollection. I close with a kiss.

As the weeks passed, Alessandro tried not to dwell on the fact that Irma's letters were becoming increasingly sporadic and vague. She was busy too, he told himself when he could no longer hear her formerly loving and flirtatious voice in her letters. But busy with what? he couldn't help but wonder.

When the time since her last letter grew to two whole months, he had to admit that he was feeling more and more uneasy about the state of their relationship. He knew he had to do something. He turned back to the book for assistance. It was a little dusty now, having languished unopened on the shelf for so long.

> My dearest Irma:
> Since I have left you, all sort of pleasure have been worthless to me. All I think of is you. I still remember your kind word before parting, and I have great hope that you have not forgotten me. A continued silence would be an immense suffering for me, and you will permit me to say the intense love I feel for you, and may I hope that some day I can marry you.
> Allow me to express to you again, the expression of my intense love and believe me, Irma, if your love is true and sincere for me, tell me so and I will be yours for ever.

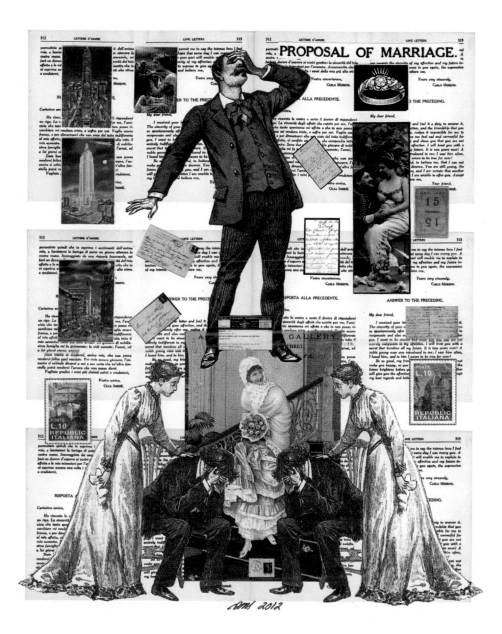

And so he waited.

Weeks passed.

The family business flourished, his father felt better, Alessandro felt worse. Each day he didn't hear from Irma, he tried desperately to convince himself that this was the fault of the postal system, which was no more reliable in the New World than it was here in the Old Country. But eventually the truth was told. His inimitable illustrious iridescent Irma was also going strictly by the book. Her letter, when it finally arrived and Alessandro clutched it to his nose, was not perfumed this time and the stationery did not feature hearts and cherubs.

My dear friend:

I received your letter and feel it a duty to answer it. The sincerity of your affection makes it impossible for me to reciprocate and also makes me feel sad and sorrowful for you. I want to be sincere and show you that you are not entirely indifferent to my affection. I will trust you with a secret that involves all my future. Another noble young man was introduced to me; I saw him often, I loved him, and to him I swore to be true for ever!

Be so good, my friend, to believe me, that I cannot make you happy, as you deserve. You are still young, the future brightens before you, and I am certain that another will give you the affection I am unable to offer you. Accept my best regards and believe me,

Your friend, Irma.

Shocked but not entirely surprised, Alessandro in his anguish ripped the book in half and tossed it in the kitchen garbage can, pushing it down with both hands until it was covered with coffee grounds, orange peels, pizza crusts, and the remains of a chicken carcass his mother had just boiled for soup.

He went upstairs to his room and threw himself down on the bed, his face smeared with tears of heartbreak and humiliation. He cried so hard and so long on the letter that the ink ran in streaks down the page and the

words disappeared one by one, leaving nothing behind but faint blue shadows where they had been. Eventually the paper itself fell into soggy pieces and then disintegrated in his hands.

He slept.

📖

Many hours later, with darkness just beginning to fall and the chill of night seeping into his room, Alessandro heard footsteps on the stairs and then a gentle tap on his door. His mother stepped silently into the room with a bowl of chicken soup in one hand and the now filthy and stinking pieces of the book (damn book!) in the other. She set the soup on top of his dresser right next to Irma's photograph and sat down on the bed beside him. She stroked his forehead and pulled the blankets up over his shoulders, tucking him in gently as if he were still her little boy.

With the broken book in her hands, she whispered, Oh, my dear sad boy. Now you know why I didn't want you to go to the New World. Now let me tell you the story of what really happened to your great-great-great-grandfather when he went to the New World. There was a woman, of course. There is always a woman in these sad stories. Now what was her name?

Let me think.

Ingrid?

Iris?

Isolde?

Irene?

Irma? Yes, that's it! The woman's name was Irma.

A Nervous Race:

222 BRIEF NOTES ON THE STUDY OF NATURE, HUMAN AND OTHERWISE

From:

Seaside and Wayside:
Nature Readers Numbers 1 to 4
by Julia McNair Wright
(Boston: D. C. Heath & Company, 1887, 1888, 1892, 1902)

Most of this text is taken from *Seaside and Wayside Nature Reader No. 3*,
with a few additions from the other volumes of the set.

Julia McNair Wright was born in Oswego, New York in 1840, and died
in Fulton, Missouri in 1903. She was married to a clergyman who later
became Vice President of Westminster College in Fulton. An extremely
prolific writer, she published nearly ninety books in her lifetime. In all of
her writing, Wright's primary concern was the state of the human soul.
She wrote novels, short stories, religious tracts, poetry, history, cookbooks,
moral lessons on temperance, and this very popular four-volume series of
Nature Readers for schoolchildren. I have used Wright's sentences exactly as
they appear in the original texts, except in a few cases where I have changed
pronouns and verb tenses for consistency.

But will they understand it if I tell it this way?
Yes, they will. They will surely understand it.
But will they care about it?
That I cannot guarantee.

—Renata Adler, *Pitch Dark*

1. **I SING AN OLD SONG** when I say that we are a nervous race, and our children are more intensely nervous than their parents.

2. In this book I shall tell you the secret of this. Then I hope you will wish to find out more of the secrets for yourselves.

3. We bring no cat and dog stories, no tales of monkey antics here. To enjoy this story you should get a bowl, or pot, of earth, and seven green beans.

4. Let us get at the truth of this matter at once!

5. Yes. The earth is a great treasure box, out of which come all things which we see about us. Every part of you, except the mind and soul part, comes from the earth. Suppose that I could take away from you all that you get from the earth. What would you have left?

6. If I could take from you all you have from the earth, you would have no house, nor food, nor clothes. You must go and sit out-of-doors, in a very sad state. All your money will be gone with the rest of your losses.

7. You must lose your straw hats also.

8. "Stop! stop!" you say.

9. I say, "No."

10. The antidote for this nervousness, and its consequent train of disasters, is to be found in the serene calm of nature, in the peaceful joys which the investigation of nature affords us.

11. Let us go out and take a walk together. So many people breathing here makes the air bad. Suppose we go into the country.

12. Come into the field. Pull up some grass. Get a carrot from the garden. Cut down a rose or a lilac stem. Break open one bean. Look at the strawberry beds. Notice a butterfly. Watch a bee. Now notice the hen. Watch the swallow as he flies. Listen.

13. The woods and the fields would be very dull and silent without the song of the birds. Even the shrill chirp of the sparrow is a pleasant sound to hear. It gives us an idea of happy life.

14. Many years ago, a great poet wrote a song to the grasshopper. In this song he said that the grasshopper was the happiest of all living things. It did nothing but dance and sing; it ate fresh leaves, and drank cool dew. When the glad summer of its life was done, it died; it did not live to be sick, or hungry, or cold.

15. Well! Well! There are many wonders in this world!

16. At five in the morning the common morning-glory and the poppy open. At six the yellow hawk-weed and dandelions look out on the

1. I sing an old song when I say that we are a nervous race.

3. We bring no cat and dog stories, no tales of monkey antics.

5. Yes.

The earth is a great treasure box.

1 2. Notice a butterfly.

1 8. Look at your mother's roses.

wayside. At seven the water-lilies smile at us. At eight, if the day is fine, the pimpernel opens its red eyes.

17. Later still the night primrose puts out its white bloom, and at two o'clock in the morning the purple convolvulus wakes up and wonders why the sun is so late.

18. Look at your mother's roses. Some are white, others are red, pink, or yellow. None are ever blue. The little child, before it can speak, will hold out its hands for a bright red rose or a golden lily.

19. What a fine yellow, red, purple, we find in plums! Is there any yellow brighter than that of the Indian corn? What is more golden than a heap of oranges, or of lemons? Is there a red gayer than you find in the apples you like so well?

20. Grapes and blackberries make your lips and tongue purple.

21. Oh, where does all this color come from? Why is it always just in the right place?

22. I cannot tell. That is one of the secrets and wonders that no one has found out.

23. One day I was sitting behind some rocks on a little island. All at once I heard a hearty laugh. I rose up softly, and looked over the rocks. I hid my head and gave a loud "ha! ha! ha!"

24. Did you ever do this?

25. In New Jersey I once saw a large, hollow tree, in which a goat lived. He was a big goat. He jumped about and slept inside the tree. When

the children called him he came out to draw their cart. In another hollow tree I saw a very nice play-house.

26. A Frenchman, who loved to study plants, made a mistletoe plant grow on a cannon-ball. Another mistletoe sprouted and grew from a seed held out on the point of a copper needle.

27. Why is that? Can you not guess?

28. In a museum I saw a bird with a bill as wide as my hand, and longer. It looked heavy enough to make the bird fall down. That bird could not swim. No.

29. Have you never found a lark's nest low among daisies, grass, and but-tercups? I think most birds like to have a pretty home. I am sure you will hurry past, and not terrify the dear little thing.

30. Turkey hens are very good mothers. But I am sorry to tell you that the handsome blue jay is very cruel to other birds.

31. I used to like to watch great flocks of crows going at sunset toward their roost. In the morning they returned.

32. But where are the other birds? Are they all dead?

33. When I was a child, I read that swallows, cuckoos, corn-crakes, and other birds, would lie torpid all winter. The book I read told me that the birds would cluster in great masses, silent, nearly frozen, eating nothing, and in the spring would wake up fresh and gay. That is not at all true.

34. Dear me, no!

Turkey hens are very good mothers.

3 0.

But

I am sorry to tell you

that the handsome blue jay is

very cruel to other birds.

4 0.

"I do not want to hear about moths,"

said a little girl;

3 5.

Describe an egg.

I kill all I can see.

4 4.

But stop a minute.

35. Describe an egg. It has a shell. Inside the shell is the clear white. Inside the white is the yellow ball, or yolk. In the yolk you may see a tiny spot, which is the germ out of which the young chick will grow.

36. What can you say of a bird's bones? What can you tell me about a bird's neck? What else can you tell me about feathers?

37. Once I was walking in a garden with a very little boy. A flight of yellow butterflies came over a tulip bed. "See! see!" cried the child, "the flowers are loose, and are flying away!" The little boy ran screaming back to me.

38. How does a butterfly spend its time? It would be very hard to tell.

39. I have found very lovely little moths clinging to the window-panes, early in the morning. Is not that pretty? What can you tell me of the beauty of moths?

40. "I do not want to hear about moths," said a little girl; "I know all about them. I kill all I can see. I killed a big, white one last night. They do so much harm. They ate up my mother's best muff!"

41. I never saw a boy who did not think that a trout was one of the prettiest things ever made.

42. Once I watched a great fish swimming. He never seemed to stir from his majestic calm. He stole across the line of vision, but without visible effort. He seemed to feel himself alone, and to notice nothing.

43. You should watch fish for yourselves.

44. But stop a minute.

Here is the truth.

So the fish chokes to death.

You know that bubbles do not last long.

Could you run with one leg gone?

The butterfly is an insect with far more beauty than sense. We may say it is an insect with very little brains.

45. Do you think you know a little about how to use your eyes as you go about the world?

46. Then we shall put on some new spectacles. Your eyes will be worth many times as much to you as they are now, when you learn to observe with care and to think about what you see.

47. Here is the truth.

48. You know that bubbles do not last long.

49. So the fish chokes to death.

50. Dirt is worth nothing.

51. Dead horses and other animals are buried in what is called a muck heap, until they are decayed and fall into pieces.

52. The buzzards strip off all the ill-smelling flesh, and leave only clean white bones.

53. The sun is up. It melts the bone so soft, that you can stick a needle into it.

54. The butterfly is an insect with far more beauty than sense. We may say it is an insect with very little brains.

55. I once saw some lovely pictures of leaves. They were made by a little girl. How did she make them? Could she paint? No. Such a picture is of no use.

56. Suppose someone shows you the foot of an ostrich.

57. Did you ever notice the big trunk of an elephant?

58. Do not laugh like a loon.

59. With this weapon it will also kill a man.

60. Could you run with one leg gone? If your hand is cut off, will it grow again? No, it will not.

61. Do not forget that your skin is full of little pores. They need to be kept open by plenty of washing; then your skin is breathing all the time, and you are likely to be well and strong.

62. Look at yourself. You grow. Your skin is soft and fine. As you grow more and more, your skin does not break. Your skin gets larger as your body grows. Suppose you did not eat? Would you grow? You have a stomach where the food that you eat is so changed that it will make for you good blood. If you stop eating you will shrink up, and be thin, and even die.

63. All animals do not have thick, red blood.

64. If you strip all the meat off a chicken's wing-bones, you will see a kind of rude pattern of a man's arm and hand, with a thumb and two fingers.

65. Does not that seem a wonder, now that you think of it? Perhaps you never noticed it before. It is one thing to see things, and another to notice them so that you think about them.

66. When we are quite ignorant of a subject, we are apt to think it has no interest.

67. I knew a boy who told his sister that "they said at school that plants had little guns." He thought the word pistil meant something to shoot with!

68. Off he went, quite satisfied with his answers. He was content, because he knew so little. If he had known more, his answers would not have suited him so well. If they are wrong, they will give you false ideas.

69. In fact, the longest life is not long enough in which to learn even what is to be learned of very simple and common things. There is danger that when we have learned a little we shall become proud, and that we shall not take the trouble to learn the very much more which we do not know.

70. Once, when I was a little girl, I ran one morning to the garden, and said to the old Scotchman who worked there, "Today I am going up the mountain for berries." "No, no, Missey, not today," he said; "it will rain."

71. "No, it will not rain," I said. Sure enough, by noon, the rain was pouring down.

72. In this water, creeping insects fall and drown. When they are dead, the bodies turn over and float on their backs.

73. Tulips are careful not to open their cups very wide in the morning, if it is likely to rain. The roses make no change; they seem not to fear wet.

74. Crickets are fond of moisture. They are thirsty creatures. They will drink any liquid left in their way. They drink water, milk, soup, tea, beer, vinegar, yeast. I have known them to come to my ink-bottle to try to drink the ink. But that killed them.

75. You might try it sometime, and find out if this is so.

76. The grasshopper should have been dead an hour or two, before you try to stuff it. Take it by the head and pass the needle through from the back end of the body, and bring it out under the breast.

77. That is cruel. How can you do that?

78. It is dead; it will do no good to water it.

79. Tell me what harm locusts do. They fill the sky like a great cloud, so that the day is darkened.

80. The only good that poor people can get from the locusts is by eating them. They pull off the wings, and legs, and dry the bodies. They eat them fried in oil and salt, or ground into meal, after roasting.

81. A little fish in the Caspian Sea is so oily that when it is dried its body burns with a clear light. These dried fish are used as candles. When the Cossacks get hungry, and have nothing else for supper, they eat their fish candles.

82. What do they do then? They seem to suffer little from such a loss. It is cruel to waste life.

83. Once I read a tale of a queen, who gave all that she had to her youngest son, and ordered all his brothers and sisters to be his servants. I did not think that that was fair.

84. Well! Well! Here is a sight! What is this on the ground? What is this other thing lying here?

85. It is red as a drop of blood. It has a jet black mark on one side.

86. Do not touch them.

87. These are not the relics of a fairy ball, but of a cruel murder.

88. The gay concerts are ended.

Tell me what harm locusts do.

The only good that poor people can get from the locusts is by eating them.

Once I read a tale of a queen.

For you must know that snakes are cruel enemies of birds.

Tulips are careful.

89. Do not bury them too deep. You might have a large piece of work on your hands.

90. For you must know that snakes are cruel enemies of birds. You must leave it to them.

91. You will notice another thing.

92. That makes her angry. She rules all. She wants it just right. She scolds and cries. But, in the end, she takes care of it.

93. Her legs are like gold. She is fine! She fights so bravely that she drives him away. She has a sharp knife. How does she use that?

94. I will give you half an hour to find an answer that will suit you.

95. She never told me whether she could or not.

96. Perhaps it is too hard.

97. What are called "love birds" are very small and beautiful parrots, from North Africa. They are as small as bluebirds. They are the smallest of their race and rather rare.

98. I remember how happy I was when my father brought me three of them, when I was a little girl.

99. At first they lay side by side. Did you ever see that?

100. They did this for five years.

101. What good does that business do us? Of what use is it?

102. The curious reasons for this, you must learn when you are older. I can now tell you only a little about it.

103. Mention some of the lost birds.

104. I had a cousin who at dusk would sit with me in a corner of the big sofa, and repeat to me a poem, called the "Prisoner of Chillon" by George Gordon, Lord Byron.

> There were no stars—no earth—no time—
> No check—no change—no good, no crime—
> But silence, and a stirless breath
> Which neither was of life nor death;
> A sea of stagnant idleness,
> Blind, boundless, mute, and motionless!...
> It was at length the same to me,
> Fetter'd or fetterless to be,
> I learn'd to love despair...
> My very chains and I grew friends,
> So much a long communion tends
> To make us what we are....

105. That sad poem had made me feel very sorry for all prisoners.

106. But it is very easy to be mistaken, and I was wrong too.

107. Let us have a look at some of these fine fellows. Here are a few facts to begin with.

108. Some grow and die in a few hours, or a day. Others live only a year. Some are said to live three thousand years. Some of them look very old.

That sad poem had made me feel very sorry for all 105.

prisoners.

"Prisoner of Chillon."

109. Mention some of the lost birds. 103.

the famous dodo.

Some are not at all pretty.

It is a bad thing, it seems, to have no head. Without a head who can take care of himself?

113.

109. Some are round, some square; some are smooth; some are rough. Some are not at all pretty. Some are very pretty. All are very queer. Sometimes they are yellow, or of other colors. Some are red, some white, some blue, some green. There are more blue ones in spring than at any other time of the year. Some have purple spots, some are brown with red spots. As they grow, they become darker and have hairs on them. These hairs are called tentacles.

110. Some shine with a clear, steady ray, some quiver, tremble, disappear, and reappear.

111. Suppose you count and see how many kinds you find. You will tell me that some are thick, some are thin. Some have veins like a net, some have straight veins. Some have lines and dots as if they were carved. Some are shaped like hearts, some like arrows, some like shields, some have smooth edges, some have edges pointed or scalloped. Think how they differ in size.

112. They differ also in smell. Some smell sweet; some smell bad; some have no smell.

113. One kind has a head on its foot. Still another kind has no head. Well! That *is* a queer thing, to have no head! It is a bad thing, it seems, to have no head. Without a head who can take care of himself?

114. Some of them are very amusing.

115. They are found in nearly all climates and countries. Wherever we go, they are our near neighbors. They live in large flocks. They are notable for size, splendor of plumage, long life, and power of learning to speak. They soon become more like wolves and panthers than decent dogs and cats.

116. Which one carries a light?

117. All have the same general way of killing and eating.

118. Their mouths are always wide open, crying for food. How do they get their nourishment?

119. If given plenty of water, clean cages, plenty of light, and good fresh seed, they will be healthy and live a long time. When captive they eat sugar, crackers, and almost any little dainty that is offered to them. They are fond of water, and bathe often.

120. Sometimes they learn to know those who feed them, and will come when called.

121. You should give them a lump of sugar for a treat.

122. Now and then, he finds a long, soft thing that looks good to eat. It is six inches long.

123. In general, they are horny like your fingernail, but thinner.

124. They were not at all afraid of me.

125. They know a man with a gun, as far as they can see him.

126. Is not that cunning?

127. In spite of the guns, the bobolink seems now in the gayest hour of his life. Why this is no one can tell.

128. Some are timid, and hide at the least sound. Others are fearless, and lie in plain view, or boldly follow their prey. Their fierce eyes shine.

They exhibit fear and anger, but almost no wisdom or anything that seems like reason.

129. He is quick to get cross. Are you? He likes to fight. In that he is like a bad boy.

130. They may have their little quarrels among themselves. Very many have some weapon for securing prey, or fighting their enemies.

131. Now he is ready to fight! What does he do? He runs at his enemy! See it shake! He has run up and hit it with his head.

132. Who are these foes? What are some of the weapons?

133. When shut up in a box, they will fight, and the one which gets killed will be eaten by the victor.

134. You have heard how they kill each other. What is there to save the poor things?

135. Countless numbers may be killed, but there are countless numbers to follow.

136. Of the creatures which it is most easy to kill, very many are born. And so, while many of them perish each day, many are left to live.

137. That is its story; that is what it was made for, to bring out others like itself.

138. What use do they serve? Have all things a use? Yes. God made all things; and all things are of use. Sometimes we cannot find out the use.

139. Here is a verse about them. As it has long, hard words in it, I wish to say that I did not make it.

> What's this I hear
> About the new carnivora?
> Can little plants
> Eat bugs and ants?
> Why, this is retrograding!
> Surely the fare
> Of flowers is air,
> Or sunshine sweet.
> They should not eat,
> Or do aught so degrading.

140. Let us watch them as they live with the snowflakes flying about them. It is as if some turned their faces, and some their backs, to the sun. At evening you find them bending toward the west.

141. Some have little hooks on them to hold them to the ground so that they may not blow away. Some will twine and climb in hot weather, and stand up straight alone in cool weather.

142. What is the reason for all these queer actions?

143. Some spend most of their time in the trees.

144. How does he do that? How are fishes able to climb trees? Let us see.

145. Now up, now down! Now here, now there! He wheels, he makes a dash! Did I not once tell you how fast they move?

146. Would you not love a bird which has such pretty ways?

147. "No, you would not," said the big boy.

148. "Since no one can suit you," said my brother, "you had better find out for yourself."

149. "O you silly girl!" cried all the rest.

150. People who have seen these big, bright things flying in the dark have been so foolish as to get frightened. I hope if you think of being afraid at any time, you will first make sure what it is that you are afraid of.

151. Finally they go in. To go in is easy. But once in, they cannot get out. The little door will not open outwards.

152. Now he is held fast, like a rat in a trap!

153. Why is this? Why do they not come out? That is a very great question, but we will try to find a little part of the answer.

154. If they did not do that, we should soon all be dead. Can I make that plain to you?

155. What did he do? He tried again. It was of no use. Then he looked much surprised.

156. Soon he liked it well. It made a very nice, safe home. His enemies could not get at him. He grew fat and big. He ate potatoes, carrots, turnips, and bread and milk, which he especially liked. He grew so big he could not get out. He began to grow to fit the shape of his cage. After some years he was a very queer-looking fish.

157. Tell me about some pretty fish.
Tell me about the sundew.
Tell me about the Venus flytrap.
Tell me of the butcher-bird.
Tell me how the grasshopper changes.
Tell me about butterfly eggs.
Tell me the history of the bobolink.
Tell me all you can about the silkworm.
Tell me about the backbone.
Tell me about the sleep of leaves.
Tell me about the cells.

158. What can you tell me about the shark?

159. I tell you about them now lest you make the same mistake that I did. I shall tell you some of the secrets of their wonder-world.

160. In houses they keep quiet well. During the middle of the day, they are silent. Perhaps they sleep.

161. They are nice for us; we like them.

162. Many of them have very sweet voices. If they have plenty to eat and drink, they will sing and be happy.

163. Did you ever hear him sing? His voice is loud, and he likes to hear it. Did you notice how he waved his long feelers gently in the heat, and seemed to bask in the glow as pussy does? If you were very still, perhaps all at once he burst into a shrill, gay little song. He is very fond of making a noise.

164. They can be taught to whistle tunes, if you train them with care and patience. Ah, there is a song for you!

He is quick to get cross. Are you?

He likes to fight.

In that he is like a bad boy.

Their fierce eyes shine.

"O you silly girl!"

Tell me about some pretty fish.

Tell me about butterfly eggs.

Tell me about the

cells.

165. He has sharp, thin feet. Look at the soles of these toes. He can run faster than a horse. I shall talk to you about feet in the next lesson.

166. He looks as harmless as possible. You can scarcely see him even if you look straight at him.

167. At this time of his life he is very helpless, like a baby. He does nothing for his neighbor, and his neighbor does nothing for him. Who shall do it for them?

168. Did you notice what a shining, dark brown coat he had? Did you see that his tail had two long, stiff hairs, or bristles, spread out from each other? When you saw all this, did you know your little friend well? Did you call him by his name?

169. What is the meaning of his various names?

170. He seemed much ashamed. He looked as if he were doing some serious thinking.

171. That is not true.

172. Some of them seem to have feeling.

173. It is very short-lived.

174. He acts as if he is in great pain. But he is not in pain. I do not think so.

175. He talks to himself constantly when alone. He is fond of peas, beans, and beets.

176. And here is still another fact. These little fellows seem to lie in wait and rush out at whatever comes by, just as little dogs dash out from

gateways! As they sweep around, they touch something which will hold them up, and at once they cling to it. Do you see a reason for this?

177. Tendrils, as I told you before, are twigs, leaves, buds, or other parts of a plant, changed into little, long, clasping hands.

178. He pops out his eyes to see all about him. Would you not look odd if you could make your eyes stand out six inches? He catches what he wants nearly every time, he is so quick.

179. Do you not see the wisdom of this habit?

180. Does not the molasses become thicker when you cook it for candy?

181. What has the plant besides honey to coax the insect for a visit?

182. They seem to get dizzy, or so full of honey, that they feel dull.

183. The temper of the creature seemed gentle; it made no noise either for joy or pain, but a low whining sound, or, if irritable, a soft growl.

184. Then they took the fish out with care, and sent him to a pond. Why do they change things in this way? I fancy it seemed odd to him to swim at first, after being so long a prisoner.

185. This sounds like a fairy story; but it is a true fairy story.

186. Which way does he go?

187. What fishes will live longest out of water?

188. We are all glad to welcome him back.

What can you tell me about the shark ?

1 5 8.

He acts as if he is in great pain. But he is not in pain.

I do not think so.

1 7 4.

He can run faster than a horse.

1 6 5.

This sounds like a fairy story, but it is a true fairy story.

1 8 5.

189. But not so fast!

190. Then a strange thing happened! I could hardly believe my eyes!

191. He called, "Come! come!" He seemed to say, "Look at me!" There was a little quiver through all his body.

192. There is a queer thing about this caterpillar. He seems to want to frighten you! He will pinch you, if he can.

193. Is not that a queer way to show love?

194. His whole body seems alert and full of fire. On his shoulders he has black and white marks, like a skull. His horny legs hang out in front. He seems to be giving some sort of a show. Why?

195. Watch it. I have told you of some of this fine fellow's naughty ways.

196. Have you noticed how slippery fishes are? Is it not hard to hold them? If you rub your finger hard down their bodies, you rub off a quantity of slime.

197. I saw some kinds of fish asleep. A dog-fish lay asleep on the sand, with his nose in a corner, for half a day. He looked as if he were dead. I suppose the sound of the water sings him to sleep.

198. Shall I tell you about him?

199. If he has lost his mate, his home, or his young ones, or if he has been beaten in a fight, he swims off to hide, and his colors grow dull. If he has beaten his enemy, if his children and mate are quite safe in the little house where he put them, he gleams and glows like a rainbow.

200. Once I looked through a very powerful microscope, and thought I was looking at a lump of half-melted gold set full of fine jewels. But it was the scale of a fish.

201. Let us look at the head. Just on the front is the mouth. It has plenty of teeth. Just above and behind the mouth are the eyes, one on each side of the head. They never have any eyelids. There is also a knob on the forehead.

202. Many fish have very odd noses. Instead of the wedge-shaped head, with the nose and mouth set exactly on the front, the nose may be of a queer shape, and the mouth above or below. I wish you could see his queer tongue!

203. This mouth has a row of strong, sharp teeth all around it.

204. At once, he begins to eat. Then, when rested, he eats again. Many do this, but not all.

205. These little mouths are eating, eating, eating, all the time. They are fond of ham, bacon, and lard.

206. Fish have cold blood, not warm like yours. They have very keen sight and smell. Probably they have good hearing, and but little sense of touch or taste. Fish will also devour almost anything that is thrown into the water for them. They have small brains, and not very much intelligence.

207. He can kill almost any creature which is in the sea.

208. This makes me think of the fable of the greedy man, who killed the goose that laid golden eggs. Then he had neither goose nor eggs. I think it served him right.

Once I looked through

a very powerful microscope.

2 1 5.

The deep " how " and " why " of things I cannot explain.

2 0 0.

Then he had neither goose nor eggs. I think it served him right.

2 0 8.

2 0 1. Let us look at the head.

Are you there? 2 2 2. Are you quite safe?

209. This will not do. It is wrong to find a pleasure in taking away life.

210. It is as wrong to be cruel to them as to other creatures. If they are to be killed, do it quickly, and give as little pain as possible. If we do cruel acts, we make our hearts hard and bad.

211. What is to be done in this case?

212. I think we should give him the benefit of the doubt and let him live.

213. Oh, no!

214. How easy it is, in this world, to be mistaken! How often the innocent suffer for the guilty!

215. The deep "how" and "why" of things I cannot explain.

216. You understand that.

217. If all the things that come out of the earth were taken from you, you would soon perish.

218. So it makes little matter what else you lose.

219. Are those very hard words? Try and keep them in mind.

220. In these simple lessons, I tell you of only common things. I speak of the things that you can see each day. These are pretty good answers. Each has some truth in it. For the rarer things you must go to larger books.

221. We will not try to explain this further to you. You might think it dull.

222. Are you there? Are you quite safe?

WHAT IS A HAT?
WHERE IS CONSTANTINOPLE?
WHO WAS SIR WALTER RALEIGH?

AND MANY OTHER COMMON QUESTIONS,
SOME WITH ANSWERS, SOME WITHOUT

From:

A Catechism of Familiar Things:
Their History, and the Events Which Led to Their Discovery, With a Short
Explanation of Some of the Principal Natural Phenomena, For the Use of
Schools and Families
by Emily Elizabeth Willement
New and Improved Edition
(London: Arthur Hall & Co., 1854)

and

The Child's Guide to Knowledge:
Being a Collection of Useful and Familiar Questions and Answers On
Every-day Subjects, Adapted for Young Persons, And Arranged in the Most
Simple and Easy Language
by A Lady
Sixty-First Edition
(London: Simpkin, Marshall, & Co., 1903)

Are you happy? Are you given to wondering if others are happy? Do you know the distinctions, empirical or theoretical, between moss and lichen? Have you seen an animal lighter on its feet than the sporty red fox? Do you cut slack for the crime of passion as opposed to its premeditated cousin? Do you understand why the legal system would? Are you bothered by socks not matching up in subtler respects than color? Is it clear to you what I mean by that? Is it clear to you why I am asking you all these questions?

—Padgett Powell, *The Interrogative Mood*

HERE, THEN, IS A BOOK WHICH, I flatter myself, will answer every purpose.

QUESTION. What is the World?
ANSWER. The earth we live on.
Q. Who made it?
A. The great and good God.
Q. Are there not many things in it you would like to know about?
A. Yes, very much.
Q. Pray, then, what is bread made of?

What is flour? What is wheat? What injury is wheat liable to? What is blight? What is mildew? What is smut? What does it look like?

Q. Has bread always been made of wheat only?
A. No; barley, oats, and rye have been more used than wheat in former times; wheaten bread being then esteemed a great luxury.

Q. Do not the people in the north of England, Scotland, and Wales, live even now upon oaten cakes?
A. Yes.

What are oats? What is barley? What is rye? What is starch? What is bran? What is semolina? What is macaroni? What is vermicelli? What is millet? What is malt? What do you mean by *fermentation*? What is yeast? What are hops? Where is Sicily?

What is wine? What causes the difference between red and white wine? Where is Cadiz? Where is Malaga? Where is Alicant? What is Sherry? What is Tokay? What are Rhenish and Moselle? What is Pontac? What is Vin de Graves? From what is the name *Muscadel* derived? What is Burgundy? What is Claret? What is Malmsey Madeira?

Q. What prince is said to have been drowned in a butt of Malmsey wine?
A. The Duke of Clarence, brother to Edward IV.
Q. Pray, is Italy famous for wines?
A. It was among the ancients; but now its wines are thin and bad.
Q. What people always drink their wine warm?
A. The Chinese, who also consider it a great compliment to be congratulated on their ability to drink a large quantity.

What place is celebrated for rum? What is the colour of brandy when it comes from the still? What is English gin? What is whisky? What is cider? What is perry? What is porter? What is mead? What is vinegar? What is honey?

What is corn? Did not man, before the cultivation of corn, feed upon acorns? Where was corn first used? Where do the Egyptians dwell? What is maize? What is manna? What nation was fed with a kind of manna? What is rice? Is it not the principal food of the lower class of people in Asia? What is opium? What is laudanum? What is chloroform? What is tobacco? What is snuff?

Of what country is the potato a native? In what British island were they first cultivated? Is not the potato one of the most useful roots we possess? Who first planted cabbages in England? Are not turnips a most useful vegetable? What are cucumbers? What are gherkins? What is guano?

Describe the appearance of the Tea Tree. What nation first introduced it into Europe? What is pekoe? What is gunpowder tea? How often do the Chinese take tea?

What does the word *Oriental* signify?

What is coffee? Who introduced it into France and England? What place is universally admitted to furnish coffee of the finest quality? Where is Arabia? What is chocolate? Describe the Cacao-nut Tree. Of what form is the fruit? How do they make it into a drink?

Q. What is saloop?
A. A nourishing drink sold very early in the morning in the streets of London to the poor.
Q. What is it made of?
A. An infusion of sassafras mixed with milk, which is considered very nourishing.
Q. Who value this drink highly?
A. The Turks: what we use in this country is principally prepared and brought from the Levant.
Q. What does the word *Levant* signify?

What is sassafrass? What are cloves? What is cinnamon? What are currants? What are raisins? What are figs? What is sugar? What is sago? What is ginger? What is the appearance of the nutmeg? Is the mace used as a spice? What is pimento or allspice? When is the time to gather the spice? What is pepper? What is mustard? What is turmeric? What is saffron? What are cardamoms? Where are the East Indies?

Where are the West Indies? Where is Calabria? Where is Caraccas? Where is Epirus? Where is Pontus? Where is Patmos? Where is the Caspian Sea? Where is Astrakan? Where is Constantinople? Where are the States of Barbary? Where is Cambray? Where was Serica? Where is Rouen?

Q. What is garlic?
A. A bulbous root of an offensive smell and strong flavour, much eaten by the lower classes of the French, Spaniards, and Portuguese.
Q. What other people eat it to excess?
A. The Jews.

What are capers? What are almonds? What countries furnish us with this pleasant nut? What are cocoa-nuts? How does the fruit grow on this curious tree? What is the betel-nut, which we hear so much of the Indians chewing? After whom was the filbert named?

How are olives eaten? Whence came the olive originally? What nation holds the olive in great repute? What has the olive branch been universally considered? Who is said to have been cast into a cauldron of boiling oil at Rome?

Do not the leaves of the geranium yield a delightful perfume?

What are yams? What are mangoes? Describe the appearance of the Mango Tree. Is there not a tree which bears a fruit that may be used for bread? How is the bread-fruit eaten? You have given me an account of a useful Butter prepared from a plant; is there not also a tree which can supply the want of a cow? What time of the day is the best for drawing the juice?

What are melons? Are they eaten fresh? Are they considered wholesome? What species of melon is that which almost makes up for a scarcity of good water in hot countries? What are tamarinds? What are dates? What are pomegranates? Is there anything remarkable attached to the pomegranate?

From what place had we the apple? What country produced the pineapple? Whence have we cherries? What are cranberries? What are plums? What is the guava? What country produced the peach? Whence are lemons brought? What is the citron? What is the lime? Of what country is the orange a native? Where is Seville? Is not the juice of oranges a grateful and wholesome acid?

Where is Milan situated? Where is Vera Cruz? Where is Sumatra situated? Where is Genoa? Where is Naples? Where is Cyprus? Where is Mount Libanus? Where was Babylon? What are the Orkney Islands? What do the appellations *Felix* and *Deserta* signify? Where are these places?

What is butter? Did the Greeks or Romans make use of butter in their cookery? What is butter called in India? How is butter made in Chile? What is cream? What is rennet? What is cheese?

Q. Which is the richest English cheese?
A. That called Stilton, which is made in Huntingdonshire, Leicestershire, Rutlandshire, and Northamptonshire. It owes its excellence to the rich pasture on which the cows are fed.
Q. What place has rendered itself famous by presenting an enormous cheese to Queen Victoria?
A. The village of West Pennard, near Glastonbury, in Somersetshire, which, in order to evince its loyalty, resolved a cheese should be made from the milk of all the cows in the parish, and when ripened should be presented to Her Majesty.
Q. What was the size of this noble cheese?
A. It measured nine feet round, three feet one inch across, and twenty-two inches deep. It was presented to the Queen at Buckingham Palace, Feb. 19, 1841.

What is lard? What is brawn? What is suet? What is bacon? What are hams? What are Westphalia hams?

Where is Prussia? Where is Armenia? Where is Syria? Where is California? Where are the Azores? Where are the Cheviot hills situated? What part of the world is meant by Australia? What is meant by the *Archipelago*?

What immense fish is it that furnishes us with a quantity of animal oil? In what part of the sea are they found? Is the oil called castor, which is so much used in medicine, the product of an animal or a plant? Is not the castor oil much used in Nubia? How do they then proceed?

Q. What are leeches?
A. A worm-shaped animal found in muddy waters; in much use in medicine for drawing or sucking blood, which they do with three sharp little teeth.
Q. Pray, which are the most valuable or most common kinds of fish?
A. The salmon, the turbot, the cod, the sole, the mackerel, and the herring.

What is sponge? What do you mean by *polypus*? From whence are the best and greatest number of sponges brought? What is coral?

What is isinglass? What part of the fish is it prepared from? What are its uses? What else does the sturgeon supply?

Do not accidents frequently occur from sharks? Mention some of these. Pray, what is the nautilus? What is caviar? What is spermaceti? What is the anchovy? What is ketchup? What is catgut? What is remarkable of the hair of the camel? Is not the skin of the ass useful for many other things? Were not wolves once very numerous in England?

Q. Is not the hunting of bears a principal employment of the inhabitants where they are found?
A. Yes; and it is a most profitable pursuit.
Q. Should we not adore God for the kind provision and comfort He furnishes, in all countries, for His creatures?
A. Yes.

Is not fox-hunting a favourite diversion in this country?

Q. Of what country is the leopard a native?

A. Of Africa; it is found principally in Senegal and Guinea; but there are leopards in Persia, India, and China.

Q. Is it not extremely savage?

A. Yes; and it is caught, like the tiger and lion, by digging deep pits, which are lightly covered over.

Q. Is it not a mark of the kindness of the Creator, that these savage beasts go in search of prey during the night?

A. Yes; for in the day, when man is abroad, they usually sleep in their dens.

Pray, where are Scinde and the Punjaub situated?

Q. Is not the extent of India very great?

A. Yes: it is about fifteen times the size of Great Britain, and contains a population estimated at 200 millions.

Q. Are we not responsible as a nation for the well-being of this immense multitude?

A. Yes; God has made England the most powerful of all nations, and we ought, therefore, to govern with mercy and justice.

Q. Why?

A. Because if we do so, He will continue to bless and prosper us.

Is there not a difference of opinion on this subject?

By whom was the Tower of Babel created, and why? What remarkable event followed their foolish pride? What good effect did this event produce?

How many churches did Sir Christopher Wren build in London?

Explain the term *Pope*.

Who was Leo the Tenth? Who was Galileo? Who was Roger Bacon? Who was Pliny? Who was Sir Francis Drake? Who was Sir Walter Raleigh? Who was Lucullus? Who was Cyrus? Who was Nebuchadnezzar? Who was Pericles? Who was Alexander the Great? Who was Sesostris? Who was Nero? Who was St. Augustine? Who was Hasselquist? Who was Seigan? Who was Praxiteles?

Who was Mercury? Who was Apollo? What is a tortoise?

Who was Venus? What nation especially adored her?

Who were the Athenians? Who were the Cretans? Who were the Sicilians? Who were the Ionians? Who were the Venetians? Who are the Maltese? Who were the Phoenicians? Who were the Franks? Who were the Goths? Who were the Lombards? Who were the Pisans? Who were the Scandinavians? Who were the Saracens?

What were the Crusades? What is meant by *The Virgin*? Which is Palm Sunday? What is a saint? Who was exposed to the Nile in a basket of papyrus? Pray, what great king was nursed in the shell of a tortoise? What is the turtle? Did not the Romans set a high value on eels? What is a lamprey? Which of our kings died from eating too heartily of them?

Q. When does history record the first use of forks?
A. At the table of John the Good, Duke of Burgundy, and he had only two.
Q. Did the family and their servants take their meals at the same table?
A. It was in those times the custom to do so.

Does not a pair of scissors occupy more time in the making than any other article of cutlery? Of what are pins made? Does not a pin, before it is fit for use, pass through the hands of many workmen? What are needles? Are not many thousand men, women, and children, employed in making needles? Is not the work very tedious? Which is the easiest to make, a pin or a needle?

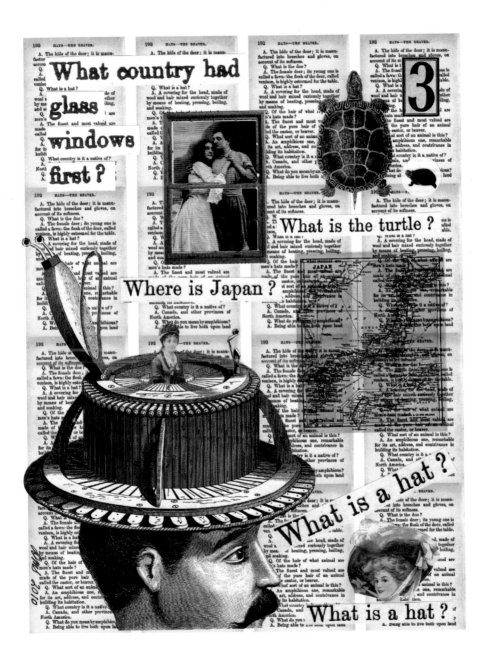

What country had glass windows first?

What is the turtle?

Where is Japan?

What is a hat?

What is a hat?

Who invented thimbles? Who invented the sewing machine? Who is said to have invented chess? Who invented musical notes? What nation was particularly celebrated for musical talents? What country had glass windows first? What city of Italy excelled all Europe for many years in the making of fine glass? What is a mirror? Are they a modern invention?

Q. What is the largest bell ever founded?
A. The great bell at Moscow, in the Kremlin. It is sixty-seven feet four inches in circumference, and was kept in a deep pit, where it was originally cast, and weighs 443,772 lbs.
Q. What bell is occasionally heard in London?
A. The great bell of St. Paul's, which is tolled on the death of any member of the royal family.
Q. What other people are particularly fond of bells?
A. The Chinese.

Where is Cochin China, and the Corea? Where is Abyssinia? Where are Florence and Lucca situated? Where are Saxony and Carinthia situated? Where is the Crimea? Where are the Moluccas?

Where is Japan? Are not the Japanese an intelligent and enterprising people?

What place is famous for whips?

What are shoes? What nation wore shoes made of the bark of the papyrus? What is a mosque? What is meant by *Mohammedan*?

Q. What skins are generally used for gloves?
A. Those of the chamois, kid, lamb, dog, doe, and many others.

What is meant by the *gauntlet*?

What is a kid? What is a lamb? What is a doe? What is an elk? Is it a gentle creature?

What is leather? How is the leather prepared? What is tan? What is lime? For what is it used? Name a few of the principal furs in use.

What is cotton? What is calico? What is bombazine? What is crape? What city of France was long celebrated for its manufacture? What is cambric? What is lace? What is wool? What country affords the best wool? Who introduced the Merino sheep into England? Where were carpets originally made? What is baize? What is linen? What is flax? What is holland? What is canvas? What is flannel? What is mohair? What is velvet? What is damask?

What is diaper?

What is a hat? Is it not extremely beautiful? Where does it come from? Is it not very useful as well as amusing? Was not her lover surprised when he saw it? What did she mean? Who was he? Was he not looked upon as a magician in those ignorant days? Did she entirely forsake him? What became of him? Did this not excite suspicion? When were guns first generally used? What purposes does this answer? How was this accomplished? Was he successful? How can you account for this? What is now the prevailing opinion? What is the other? What was it good for?

What are the muscles? What are the lungs? What is the balm of Mecca? What is the balm of Gilead?

Where was Carthage? Where was Troy? Where was Etruria situated? What country is meant by Mauritania? Where is Mexico? Where is Jamaica situated? Of what country is Stockholm the capital?

Why were the ancient Egyptians so anxious about preserving their dead? What is an obelisk? What is a pyramid?

Q. Do not different countries adopt different colours for mourning?

A. Yes; in Europe the ordinary colour for mourning is *black*; in China it is *white*, a colour which was the mourning of the ancient Spartan and Roman ladies. In Turkey it is *blue* or *violet*; in Egypt, *yellow*; in Ethiopia, *brown*; and kings and cardinals mourn in *purple.*

Q. Does not every nation give a particular reason for the particular colour they assume in mourning?

A. Yes; *black*, which is the privation of light, indicates the privation of life; *white* is an emblem of the purity of the spirit, separated from the body; *yellow* is to represent that death is the end of all our earthly hopes, because this is the colour of leaves when they fall, and flowers when they fade.

Q. What does *brown* denote?

A. The earth to which the dead return; *blue* is an emblem of happiness, which it is hoped the dead enjoy; and *purple* or *violet* expresses a mixture of sorrow and hope.

What do you mean by *decomposition*? Give me an example. Give me another example.

Q. What is understood by *magic*?

A. Magic is a term used to signify an unlawful and wicked kind of science, depending, as was pretended, on the assistance of devils and departed souls. The term was anciently applied to all kinds of learning, and in particular to the science of the Magi or wise men of Persia, from whom it was called *magic.*

Q. What great hero was more timid than a woman in a coach?

A. Henry IV of France; for it had been foretold by an astrologer that he should die in one.

Q. Was this prediction verified?

A. Yes; for he was stabbed by Ravaillac during a state procession, May the 14th, 1610.

Q. How did he reach him?

A. He jumped upon the hind wheel, and plunged a knife into the breast of the king, who was reading a letter.

What then?

How was gunpowder invented? But who discovered its great and destructive powers? When was it first used in battle? Is it not said that the Chinese were acquainted with gunpowder long before this period? In what reign was a conspiracy formed to blow up the Parliament-house, together with the King, Lords, and Commons, with gunpowder?

Are we to believe that we see every thing that inhabits the earth? When were spectacles invented, and who was their inventor? What is a telescope? Who invented Astronomy? What is Geometry? What is meant by *Mechanics*? What is a microscope?

What is a barometer? What is meant by *hermetically sealed*? What is the appearance of mercury? What is a thermometer?

Q. What is a telephone? Can you give me any instances of its practical operation?
A. Yes; a short time ago the late Queen Victoria, while in her drawing room at Osborne in the Isle of Wight, listened to the sounds of instruments played at Southampton, and to a song sung by a vocalist in London.
Q. Have conversations been carried on by means of a telephone?
A. Yes; in November 1878, some gentlemen at Norwich conversed for a long time with others in London, over a distance of more than a hundred miles; and the voices transmitted were so clear that the American accent of the gentleman in charge of the Norwich end was distinctly recognizable in London.

What is Chemistry? By what other name has Chemistry been known? What was the Philosopher's Stone? Was this search successful? Was any gold ever produced by this method? What do you mean by *carbon*? What is oxygen? What are the properties of nitrogen or azote? What is caloric? What is hydrogen? What is meant by *gas*? You inform me that Chemistry enables us to discover the properties of bodies by means of *analysis* and *combination*: what do these terms imply?

Which is supposed to be the most natural state of all bodies?

Explain the terms *Repulsion* and *Attraction*. Give me some examples of Repulsion. What is the influence of Attraction? Relate a few more of the advantages obtained by a knowledge of Chemistry. What is the cause of bodies swimming in fluids? Who first taught the true system of the Universe? Is not this a little doubtful? What does the word *Nature* signify?

What is twilight? How is it produced? What is the poetical name for the morning twilight? What remarkable phenomenon is afforded to the inhabitants of the polar regions? Of what nature is the Aurora Borealis? In what country is it seen constantly from October to Christmas?

Q. What is dew? What is its use?
A. A moist vapour drawn by the sun from the earth and water, and condensed or thickened; this very light, thin, insensible mist again falls, while the sun is below the horizon. It cools and refreshes the vegetable creation, and prevents it from being destroyed by the heat of the sun. Egypt abounds in dews all the summer; for the air being too hot to condense the vapours in the daytime, they never gather into clouds, and hence there is no rain there. All hot countries where there is little or no rain are therefore blessed with this provision by the all-bountiful Creator, to render them luxuriant and inhabitable.

Where is Egypt? Where is New Guinea? Where is Aroo?

Q. What is the bird of paradise? How are these birds caught? What do hunters do with them as soon as they are killed?
A. They cut their legs off, take out their insides, and dry them in smoke; they then send them to Banda, and other settlements, for sale.
Q. Were there not some extraordinary ideas of this bird?
A. Yes; it was thought they had no legs, that they were constantly flying, and never touched the earth till their death, and that they fed only on dew.
Q. How did these ridiculous notions arise?

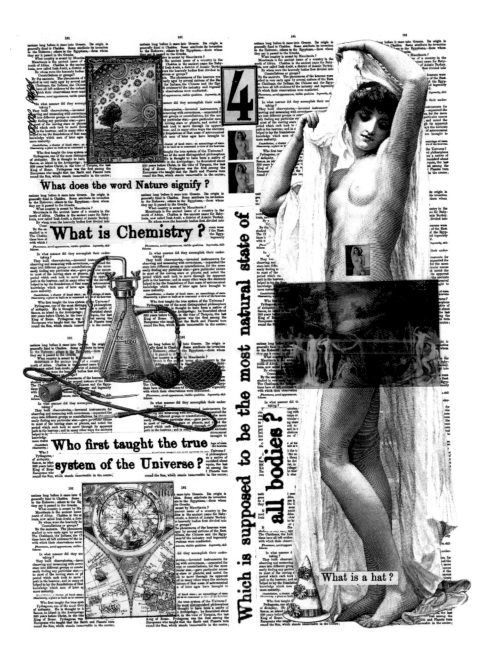

What does the word Nature signify?

What is Chemistry?

Who first taught the true system of the Universe?

Which is supposed to be the most natural state of all bodies?

What is a hat?

A. Probably from the beautiful nature of their plumage, and their being sold without insides or legs.

What is the ostrich? Are not the eggs of the ostrich esteemed even among Europeans as palatable and very nourishing? But is this not probably an error?

Q. What bird furnishes military plumes?
A. That beautiful bird, the common cock of our farmyards: the long streamy feathers of his neck and back, and the stiffer ones of his tail, are formed by industrious females into a variety of elegant shapes, according to regimental regulations.

Q. Is not the peacock a beautiful creature? How many feathers are there in the peacock's crest?
A. Twenty-four.
Q. How was this bird served up in Shakespeare's time?
A. In a pie; the head, richly gilt, being placed at one end of the dish, and the tail spread out in its full circumference at the other, stuffed with spices and sweet herbs.

What else must be done to it? Are all bodies equally combustible?

What is water? Does Nature decompose water in any of her operations? Of what use is this power to vegetables? What is rain? What is snow? What is hail? What is the atmosphere? What are its uses? What is wind? What is thunder? What is lightning?

Q. What is electricity? What bodies does it pass through? To what part of bodies is electricity confined? Name a few substances possessing this remarkable property.
A. Silks of all kinds are highly electric; the hair and fur of animals, paper, sulphur, and some other minerals; most of the precious stones; and many other substances used by us in the common affairs of life, are susceptible of electrical excitement; among domestic animals the cat furnishes a remarkable instance of this fact.
Q. How so?

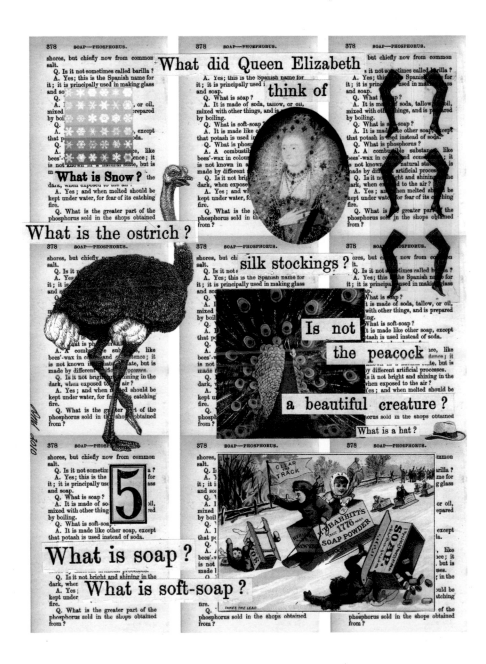

A. Because, when dry and warm, the back of almost any full-grown cat (the darker its colour the better) can be excited by rubbing it with the hand in the direction of the hair, a process which is accompanied with a slight snapping noise, and in the dark by flashes of pale blue light.

Q. Give another example.

Are not the skins of cats a very considerable branch of commerce in some countries? Was not the skin of the lion considered a badge of great honour? Did not the Romans tame this noble beast in a wonderful manner?

Of what countries is the elephant an inhabitant? Is not its strength immense? Is it not exceedingly circumspect? Are there not white elephants? Are they rare? Is not the finder of one of these rare creatures a most fortunate mortal?

Is not the silk-worm a very curious insect? How much silk is each ball said to contain? What is meant by *chrysalis*? Where was silk first made? Who introduced the silkworm itself into Europe? Where were the cities of Thebes and Athens situated? When did the use of silk come to England? What was the Edict of Nantes?

Pray, is the worm killed?

Q. What did Queen Elizabeth think of silk stockings?

A. In the third year of her reign she was furnished by her silk woman with a pair; which she admired "as marvelous delicate wear," and she would never afterwards use cloth ones.

Q. Was not this Queen very fond of dress?

A. Yes; it is said that after her death, three thousand different habits were found in her wardrobe.

Q. Were not the ruffs of the ladies very large during Queen Elizabeth's reign?

A. Yes; we are told that persons used to stand, by order of the Queen, at the gates of the city, for the purpose of cutting down every ruff that was more than a yard in depth.

Q. How long did this ugly fashion last?

A. Only to the middle of the reign of James I, when a Mrs. Turner (an accomplice in poisoning Sir Thomas Overbury) being hanged in one, put them completely out of fashion.

What is verdigris? Is it not a rank poison?

Q. What is copper?
A. A red-coloured metal, and the most sonorous of all metals.
Q. How many kinds of copper are there?
A. Three; the common, the rose, and the virgin.
Q. What are the uses of copper?
A. They are too various to be enumerated.

What is lead? Where is lead found? What is peculiar to the ore of lead? What is platina? What is sulphur? Are not its uses very extensive? From whence are the greatest quantities of sulphur brought? Which is the most rare and beautiful of all the kinds? What is phosphorus? What are Lucifer matches? What is arsenic? What is oxalic acid? What is dragon's blood?

What is soap? What is soft-soap?

What is the name of the remarkable stone of which a cloth has been made, that resists the action of fire? Where is the asbestos found?

Q. What is borax? Was not the art of refining it kept for a long time a secret by the Dutch and Venetians?
A. Yes.

Name the countries most noted for mines of salt.

What is coal? What is iron? What parts of the world most abound with it? How long have iron tools been used in European countries? What do you mean by *metals*?

What are metals called in their natural state? What is brass? What is pewter? What is zinc? What nation appears to have been longest acquainted with it? For what is zinc used? What is lapis calaminaris?

What did the late Sir Humphrey Davy invent to prevent the loss of many valuable lives?

What is a volcano?

Q. Name some of the most remarkable volcanoes.
A. Towns and cities have been swallowed up, and thousands of people destroyed by them. The eruption of Vesuvius in A.D. 49, buried the cities of Herculaneum, Pompeii and others, under the flood of boiling lava which issued from its crater or summit. Thus they remained, till discovered a few years back, when the rubbish and soil was removed, and streets, houses, manuscripts, bread, fruit, grain, medicines, all in a state of preservation, were found just as they were left by the inhabitants at the time of the eruption.
Q. Name some of the islands that have been formed by volcanic agency.
A. Teneriffe, Iceland, Sicily, St. Helena, part of Sumatra, Java, Japan, and the Sandwich Isles, have been heaved up from the depths of the ocean by these subterranean fires.

What is granite? What is slate? Of what do calcareous earths or stones consist? What is quick-lime? What is saltpetre? What is steel? What are strata? Describe them. Describe a few of the principal simple or primitive earths. What are the properties of flint? Describe the properties of lime. What are the properties of clay? Who first taught his subjects to make bricks?

What is marble? In what countries is marble found? What kind appears to have been held in the greatest esteem by the ancients? What is the meaning of *opaque*? What is porphyry? What is alabaster? What is plaster of Paris? What is jasper? What is malachite? What is lapis lazuli? What is jet? What is agate?

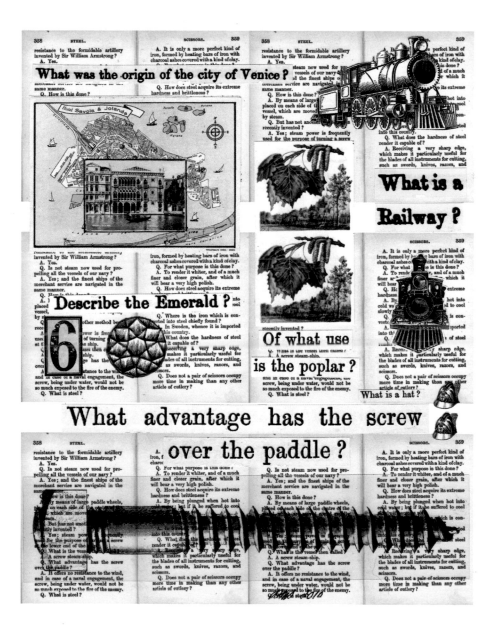

Give me a short account of sculpture in Germany and France.

What is the character of silver? What is the character of gold? What is the character of gum? When was the use of money first introduced?

Describe the diamond. Was it very large? What is the ruby? Describe the emerald. What is the turquoise? What is a sapphire? What is the amethyst? What is the topaz? Is not the garnet a very fine stone? What is the sardonyx? What are opals? What is a bort? Is there not a precious stone called the carbuncle? What sea produces the best and greatest number of pearls?

Where is Ceylon? Where is Morocco? Where is Hexham? Where is Woodstock? Where is Pegu? Where is Bohemia? Where are the Seychelle Islands? Where is Marseilles? Where is Bantam? Where is Nubia? Where is Carrara? Where is Candia? What was the origin of the city of Venice? What is the signification of *Mediterranean*?

What is navigation? Has the discovery of the magnet enabled sailors to venture into the great ocean far away from any land? Describe the Mariner's Compass. Does the needle point exactly to the true north and south? What other difficulties had to be surmounted?

When were ocean-steamers regularly established as a means of communication with foreign lands?

Is the detestable traffic in slaves still continued? Where do they come from? How can this be?

What is the steam engine? To whom are we indebted for its invention? What is a railway? What is the signification of *telegraph*? When was this extraordinary invention first brought into use?

Q. What were used before telegraphs?

A. The idea of communicating by signs occurred even to uncivilized man. North American Indians convey signals from hill to hill by throwing about their arms, holding up skins, or spreading out their cloaks.

Q. What is a canoe?
A. A little boat used by the Savages in both Indies, as well as by the negroes of Guinea; they are made chiefly of the trunks of trees dug hollow; and sometimes of pieces of bark fastened together.
Q. How do they guide them?
A. With paddles, or oars; they seldom carry sails, and the loading is laid in the bottom.
Q. Are not the Savages very dexterous in the management of them?
A. Yes, extremely so.

Are they not very handsome? How do they get up when exhausted? How are they destroyed?

What advantage has the screw over the paddle?

What is bark? What is cork? What is kamptulicon? What is cochineal? Is it a plant? Does the insect change its colour when it is dead? What is gutta percha?

Q. What are the most useful trees for cultivation?
A. The oak, elm, ash, beech, poplar, walnut, sweet chestnut, and fir.

What kind of tree is the elm? What is the wood of the beech-tree used for? Is it not very subject to the worm? Of what use is the poplar? Is not the fruit of the walnut tree in great request? Is the wood of the cherry tree useful? How long does the sap continue to flow?

Q. How many oaks does it appear, from a printed report made to the House of Commons, were required to build a 74-gun ship?

A. Two thousand trees of 75 years' growth: it requires 50 acres of ground to produce them, and they yield about 3000 loads of timber.

Q. Does not this teach us that formidable difficulties may be overcome by intelligence and perseverance?
A. Yes; and the greatness of our country has chiefly resulted from these qualities of the English people.

What authority is there for this supposition?

What is gamboge? What is logwood? What is tar? What is pitch? What is camphor? What is musk? Is there not another animal which produces a similar scent? What is myrrh? What is frankincense? What is ether? What is naphtha? What is turpentine? What is indigo? What is vermilion? What is ultramarine? What is cobalt? What is umber? What is ochre? What is annatto? What is fustic?

What is Painting? Were the Egyptians acquainted with this art? Why were the Ethiopians supposed to have introduced the art of painting into Egypt? Have we any notice of this art among the Hebrews? By what nation was the art of painting practiced with great success? Was not Raphael also reckoned as excellent an architect as he was a painter? Were not the Jewish maidens beholden to their residence in Egypt for the perfection they attained in the art of embroidery?

Q. What is Poetry?
A. The glowing language of impassioned feeling, generally found in measured lines, and often in rhyme.
Q. Is not this art of great antiquity?
A. There is not the slightest doubt of it. Most ancient people had their poets: and among the Hebrews they were called prophets.
Q. Name a few of the ancient poets.

How many pens will one ton of steel produce?

Who introduced Printing into England?

What is a clock?

What is a clock?

Has not the rose in all ages been more celebrated than any other flower?

7

What is a hat?

What is Painting?

A. David was an inspired poet of the Hebrews: Homer, one of the earliest poets of the Greeks: Ossian, an ancient poet of the Scots: Taliesen, an ancient poet of the Welsh: and Odin, an early poet of the Scandinavians.

When was the art of writing invented? What might be the earliest methods? Were hieroglyphics employed before or after alphabetic writing? How many pens will one ton of steel produce?

Of what is paper made? What materials were used for writing before the invention of paper? Have not plants sometimes been used for paper and books? What is papyrus? In what place was the art of printing first practiced? What was the first book that was printed from metal types? Who introduced printing into England? What is parchment? From what is the word *parchment* taken? How is the flesh taken off?

Were not books once made of bark? Which part did they use? Is it not also used in manure?

Q. From what language do we derive the word *book*?
A. From the Danish word *bock*, which was the beech-tree, because that, being the most plentiful in Denmark, was used to engrave on.

What is tapioca? What is rhubarb? What is linoleum? What is liquorice? What is Phoenicia? What is an author? What is signified by a glass-house? Has not the rose in all ages been more celebrated than any other flower? What is a clock?

Is it now finished? Is it necessary to know anything else?

Let us remember that "Knowledge is Power."

A Body Like A Little Nut:

IN WHICH THE BOTANIST LOOKS FOR LOVE IN THE WILD,
APPROPRIATES THE ALPHABET, WAXES POETIC,
SUCCUMBS TO DESPAIR

From:

The Commonly Occurring Wild Plants of Canada:
A Flora for Beginners
by H. B. Spotton
(Principal, Harbord Street Collegiate Institute, Toronto)
Revised Edition
(Toronto: W. J. Gage & Company, 1897)

This High School Botany textbook is arranged in proper scientific fashion according to Family, Order, Class, Sub-class, and Division. I have taken great liberties with this careful classification, selecting those words, phrases, and sentences that most appealed to me and arranging them alphabetically.

From giant Oaks, that wave their branches dark,
To the dwarf Moss, that clings upon their bark,
What Beaux and Beauties crowd the gaudy groves,
And woo and win their vegetable Loves.
How Snowdrops cold, and blue-eyed Harebells blend
Their tender tears, as o'er the stream they bend.
The lovesick Violet, and the Primrose pale
Bow their sweet heads, and whisper to the gale;
With secret sighs the Virgin Lily droops,
And jealous Cowslips hang their tawny cups.
How the young Rose in beauty damask pride
Drinks the warm blushes of his bashful bride;
With honey'd lips enamour'd Woodbines meet,
Clasp with fond arms, and mix their kisses sweet.

—Erasmus Darwin, "The Loves of the Plants"
in *The Botanic Garden* (1791)

A BODY LIKE A LITTLE NUT. A clammy-hairy weed in damp yards. A column which rises from the centre of the cell. A common pest in gardens. A few words will not be out of place. A fine large tree in rich woods. A flora for the use of beginners. A garden escape. A hirsute species. A homely weed. A low hairy annual. A poisonous annual, with an unpleasant odour, found occasionally in cultivated grounds. A pretty little plant. A pungent watery juice. A short stout prickle. A shrub forming clumps by the production of suckers. A slender and very graceful tree. A small family having, with

Floral

A floral for beginners.

A pretty little plant.

CYPRIPEDIUM HIBRIUM

POLSKA

Capitate, like a head.

A body like

a little nut.

As large as a good-sized pea.

All the

flowers

perfect.

us, but a single representative. A stout, coarse, prickly plant, not unlike a thistle in appearance. A straggling shrub with reclining branches. A tall and handsome tree. A trailing slender evergreen. A troublesome weed in Manitoba. A very conspicuous plant in early spring. A very simple task. A white-flowered variety is sometimes met with. Abortive, defective or barren. All the flowers of a head may be tubular. All the flowers perfect. Almost destitute of milky juice. Along the main line of the Grand Trunk Railway. An appendage in the throat. An obscurely hoary perennial. And the heads are many-flowered. Approaching each other in pairs. Are the parts of the corolla separate? Armed with a number of long, flat and thin spines. As large as a good-sized pea. At length long and loose. Attached by a tuft of fine hairs.

Ballast-heaps. Banks of streams, eastward. Bark easily coming off in sheets. Beak conical, usually short. Beaver meadows and wet banks. Becomes hollow like a bird's nest. Being simply based upon their sound. Being sooner or later driven against it either by the wind or by the head of some insects in pursuit of honey. Berry black. Berry blue or black, with a bloom. Berry orange, sticky. Berry several-seeded. Berry speckled with purple. Beset with long and soft as well as chaffy hairs. Beset with stiff hairs, the teeth spiny. Bogs and damp barren grounds, abundant eastward. Borders of fields, especially where the ground has been burned over. Borders of springs; common at Queenston Heights. Both persistent and becoming dry. Both species are found in dry soil. Bright green on both sides. Bristly-hairy, stout. But in some instances the plant is white or tawny. But not united together. But the berries ripen later.

Capitate, like a head. Capsule pendulous. Chaff persistent. Clearly perfect. Clearly the former. Cleft cut to about the middle. Clothed with silky hairs. Cold woods. Common everywhere along roadsides and in waste places. Confluent, blending together into one. Continually in a state of agitation. Cool mossy woods, chiefly in the shade of evergreens. Creeping with slender runners. Crevices of rocks, and sand-beaches and plains. Crimson when

ripe. Crumpled in the bud, yellow. Cup varying greatly in size, often very large. Curved and conniving under the upper lip.

Deciduous, falling off, not persistent. Deep water. Deeply imbedded in pits on the surface of the fleshy receptacle. Delicate, often crossing the vein. Depressed, flattened from above. Differs from the last in being rough. Do not collapse when withdrawn from the water. Downy, but greenish. Drooping in the evening. Dry cedar swamps and ravines in rich woods. Dry hills. Dry plains. Dry woods.

Easily recognized by the globular head. Eastward and northward. Embracing the true. Erect or reclining, armed with hooked prickles. Escaped from cultivation. Except in a very general way. Extremely common.

Falling off early. Five curious hooded bodies. Flattened when there are more than one. Fleshy, simple, and roundish. Floating on quiet waters of Lake Ontario. Flowers brown and green. Flowers chiefly blue. Flowers cruciform. Flowers destitute. Flowers few or several, remote. Flowers golden yellow. Flowers handsome. Flowers hardly an inch across. Flowers in dense heads, perfect. Flowers in white clusters at the summit. Flowers inconspicuous. Flowers insignificant. Flowers interrupted. Flowers nodding, scarlet outside, yellow within. Flowers not at all, or only slightly, sweet-scented. Flowers numerous, nodding. Flowers on slender stalks. Flowers pale yellow, opening in sunshine. Flowers perfect. Flowers polygamous. Flowers reflexed when old. Flowers regular. Flowers several, whitish, spurs divergent, elongated, acute, straight. Flowers small and dingy. Flowers small, more or less nodding. Flowers solitary. Flowers terminal. Flowers usually one, white and star-shaped. Flowers very fragrant. Flowers very showy, terminating. For the explanation of such technicalities as you may not have previously mastered. Forming thickets in low grounds along streams. Found also elsewhere. Found wild occasionally in old fields. Frequently shining. Fruit a greenish apple. Fruit a large prickly naked pod. Fruit a legume. Fruit a nut with a husk. Fruit a samara, winged all around. Fruit a small black berry.

Fruit edible.

Flowers on slender stalks.

Flowers polygamous.

Fleshy, simple, and roundish.

Found also elsewhere.

Fruit a sour berry, oblong, scarlet. Fruit as large as a pea, dark-purple when ripe, the flesh thin. Fruit black, insipid. Fruit black, without a bloom. Fruit bristly. Fruit club-shaped. Fruit covered with hooked prickles. Fruit deep blue, on reddish stalks. Fruit edible. Fruit flat. Fruit light blue. Fruit not rough. Fruit orange-coloured. Fruit ovoid. Fruit red, becoming black. Fruit red, pleasantly acid. Fruit red, sour, with a very flat stone. Fruit resembling a cone. Fruit ripening under water. Fruit smooth. Fruit twin. Fruit wing-less. Fruit with prominent acute ribs, having broad spaces between them.

Generally breaking away. Gradually expanding into the long wing above. Growing under water.

Hairy when young. Has appeared to be confined. Has escaped from gardens in a few places. Has been found in the Thames valley. Having remained naked during the winter. Having the small nut in the bottom. Heads erect. Heads few, as a rule. Heads large, solitary. Heads nodding. Heads numer-ous, small, crowded. Heads single, on the naked branches. Heads solitary, drooping. Heads terminal. Heart-shaped, often with a white spot above. Here a little doubt may arise. Here we have a single frond. Here we have something quite different from what we have so far met with. Hoods yel-lowish, with a small horn, obtuse, entire.

If successful in these attempts, he will naturally acquire confidence. If they will kindly draw his attention to any such defects. In all cases where the student meets with an Orchid in flower, he should, by experiment, endeavour to make himself acquainted with the method of its fertiliza-tion. In determination and diligence. In places where water lies in spring. In the hands of the young student. In the open throat. In which the seeds are sunk. Inner face marked with a deep groove. Is distinguished. Is loosely pubescent. Is reported as common in the prairie region. Is slender. Is smaller. Is smoother. Is the calyx superior? It can hardly be that such omissions do not occur. It is an uncommon garden escape. It is at once recognized by its tubers. It is not unusual also to find a mixture of perfect

It seems not unreasonable to hope.

Having remained naked during the winter.

In the hands of the young student.

Heads erect.

Heads terminal.

and imperfect in the same head. It is really a doubtful question. It is so obscure as to be very difficult to observe. It need hardly be added. It seems not unreasonable to hope.

Juice colourless and bitter. Juice milky. Juice pungent. Juice red. Juice watery. Juice yellow.

Key to the orders. Known to be peculiar.

Labiate, having two lips. Lasting year after year. Leafless parasitic slender twiners. Leaflets shining above. Leaves clasping, wavy, cut-toothed. Leaves floating. Leaves hair-like, bearing small bladders. Leaves heart-shaped, sharply toothed, sparsely hairy above, downy beneath. Leaves hollow, with a wing on one side, purple-veined, curved, with the hood erect and open. Leaves linear, entire, remote. Leaves radical, all shining. Leaves scattered. Leaves simple, heart-shaped, and variously lobed. Leaves simple, not clasping. Leaves somewhat rigid. Leaves with transparent dots. Less blotched than the last. Let us suppose. Lip assumes the most fantastic shapes. Lip crested and fringed. Lip flat, mostly drooping. Lip large, inflated. Lip oblong, almost truncate at the tip; a tooth on each side at the base, and a nasal protuberance on the face. Lip with three ridges on the palate. Lip with two ridges on the inner part of the face. Lip without a spur. Little thickened below the head. Long, perennial, sweet. Longer than the thick blunt spur. Loosely pubescent below, smooth above. Low grounds everywhere. Low, spreading or creeping. Lower petals veined with purple.

May be looked for here. Meadows and oil fields. Mention has been made of that fact. Minutely downy, but not warty. Moist places. More or less pubescent. Mostly in manured soil. Mostly in slow waters opening into Lake Ontario. Must therefore be looked for under the head.

No attempt has been made to define the limits. No attempt has been made to enter the Pacific coast. No floral envelopes. No plaited folds in

the sinuses. No space between. No stinging hairs. Northward, in slow waters. Not climbing or twining. Not common westward. Not containing an embryo. Not crumpled in the bud. Not depressed in the centre. Not forming tails. Not mealy, but sticky. Not so common as the next. Not succulent. Not sufficient to completely close the throat. Not surviving the winter. Now let us take the Strawberry. Nutlets shining. Nuts naked, bony, and covered with white wax.

Observe, also, the grooving of the sterile stem. Odour disagreeable. Often crimson underneath. Often much larger than the others, forming a kind of false ray. Often shaped something like a horse-shoe. On logs and about stumps in cedar swamps. On the sunny side. On the whole, we choose the latter. One species has scales. One species is without rays. Only slightly irregular. Opening in the morning. Opening only at night or in cloudy weather. Opening only for a short time in sunshine. Otherwise nearly like the last. Our most northern rose. Ovaries in a ring. Ovaries united into one berry. Ovary bursting soon after the flowering. Ovary pointed.

Pale green, with an offensive odour when bruised. Parasitic herbs, destitute of green foliage. Peculiar to the east. Peculiar to the west. Peduncles furrowed. Persistent. Petals all permanently united. Petals always absent. Petals beardless. Petals entire, bearded on the claw. Petals none. Petals pale. Petals pointed. Petals streaked. Petals wanting in our genus. Petals white, long-clawed, hooded. Petals without claws. Plainly not. Plant but little aromatic. Plant erect, hairy (but green). Plant more or less hairy, erect. Plant poisonous to the touch. Plant scarcely a foot high. Pleasantly pungent to the taste. Pod bursting elastically, and discharging its seeds with considerable force. Pod depressed. Pod elongated, erect in fruit. Pod prismatic. Pod turgid. Pods few-seeded, clothed with rough glands or short hooked prickles. Pods orange when ripe. Pods pendulous. Pods slender, erect, and spreading. Pods the size of a pin's head. Pretty easily recognized by its strict habit. Probably a hybrid between this and the next. Prostrate diffuse herbs, with a disagreeable characteristic odour. Pubescent with appressed hairs.

Now let us take the Strawberry.

Our most northern rose.

Persistent.

Labiate,

having two lips.

Rather bearing a single head as a rule.

Railways and roadsides. Rather bearing a single head as a rule. Rather ill-smell-ing. Rather less than an inch in thickness. Rather pale and only slightly mealy. Rather rare. Rays large, sky-blue. Rays yellow, many. Receptacle bris-tly. Receptacle chaffy. Receptacle naked. Rocky thickets, and in old windfalls. Roots extensively creeping. Roots horizontal, aromatic. Roots long and slen-der and tough. Rose is a far western form. Rough-hairy all over.

Scaly stem erect and rising. Scarce. Scattered bladders. See previous para-graph. Seeds in three rows on the walls of the ovary. Shady hill-sides and wet pastures. Shallow water; apparently rare. Shores of the Great Lakes. Shrubs with scurfy leaves. Slow water. Smaller than the last. Smooth and shining except when young. So different that you will hardly believe it. Something like ears of corn. Sometimes creeping in the mud. Sometimes wanting. Somewhat hairy when young, pale. Somewhat pubescent even when old. Sparingly naturalized. Special acknowledgements are also due. Species known to be of rare occurrence have been excluded. Sprinkled with little scales when young. Spur very thick and blunt, conical, gibbous. Stagnant pools. Stamens irritable. Stem erect, naked above, bearing a sin-gle large head. Stem erect, slender, smooth. Stem leafy below. Stem low and simple, hoary. Stem smooth, stout, purple. Stem turning red when old. Stem usually swollen at the joints. Sterile catkins scattered. Streets of towns. Style declined. Style dilated. Style long. Style none. Style very slen-der, much protruded. Styles distinct. Styles often united below. Submerged leaves without blades. Succulent, juicy. Suppose we answer *Yes*. Swamps and ditches and wet meadows in spring.

Tendrils with sucker-like disks at the end, by which they cling to walls, trunks of trees, etc. The branches with drooping extremities. The choice is found to depend upon such obvious characters as to furnish no difficulty. The colour of the branches and the much smaller leaves. The constant companion of the present. The denizens of our own woods and fields. The difficulty of knowing where to stop. The divisions of the lip also are narrow and the fringe is less copious. The earlier large and conspicuous,

The least motion of the air.

Succulent, juicy.

The only question

then remaining.

Suppose

we answer

YES.

the later small and pale. The European Linden is planted as a shade tree in some places. The fertile ones solitary or clustered. The first of these is not applicable. The flower is entirely destitute. The flowers are pale lilac. The flowers are rarely to be seen. The head (except the beard) is lead-coloured. The inner layer hard and bony and forming a nut-shell. The labour of determination. The latter are often pink-tinted. The latter clasping. The latter hooded, and with slender claws. The least motion of the air. The leaves and roots are poisonous. The lip usually white, spotted with purple. The lips rounded and entire. The lips very unequal, the palate open, and hairy or spotted. The lower lip conspicuously bearded within. The mouth somewhat contracted. The old bark separating in thin layers. The one we have selected is one of the commonest and at the same time one of the easiest to examine. The only genus with us. The only question then remaining. The others partly clasping. The pale violet petals also are beardless. The petals are rose-coloured. The petals are sprinkled with purplish dots. The pistil is single. The placenta is rising from the base. The plant is pretty easily met with in low wet places. The rays, also, are larger. The seeds are exalbuminous, consisting entirely of the embryo, which is folded up in a variety of ways. The seeds having been brought in wool from South America. The sinus very narrow or closed. The small nuts in crowded heads. The sterile ones silky. The teeth spiny, and spreading when old. The throat open, lilac-purple or whitish. The true Daisy. The tube elongated and somewhat curved. The two berries separate. The upper lip not arched, the throat inflated. The upper ones clasping by a heart-shaped base, entire. The use of these tentacles is doubtless to assist in the escape. The veins are free, as before. The very straight veins terminating in the teeth. The whole plant is of a purplish hue. The whole plant is stouter. The writer will be most grateful. Then you will have something. There is a slit across the middle of each, and one of the slits is partially open. There is no doubt. These burst in autumn. These examples need not be extended here. They may be remedied. This impression is confirmed. This species is evergreen. Thorns very long. Throat of the corolla almost closed. Tipped with a little head. Tipped with a sharp appendage. Tipped with crimson. To this the

Withering away after fructification.

With drooping heads.

You will look in vain.

With small widely-diverging wings.

sporangia are attached. Too common in our grain fields. Turning black on drying. Turning purple before withering.

Undergoing constant alteration from various causes. Up to this point. Usually more or less united with each other. Usually tall and stout. Usually under pines in dry woods.

Very common along fences and in moist thickets. Very fleshy (commonly prickly). Very much like the last, but larger. Very slender teeth. Very weak and brittle, supporting themselves on other plants.

Wanting, and the flowers consequently naked. Waste places and old gardens. We cannot choose any one. We find that they are not. We shall describe one species of each. Wet places in high grass. What is really desired. When young, not shining. With a black girdle. With a few remote teeth in the middle. With a long tapering extremity. With a pungent aromatic odour. With a yellowish eye and a long tube. With drooping heads. With sharp edges. With small widely-diverging wings. With something of the aspect of a violet. With the last, but floating. With the specimen in hand. Withering away after fructification. Without hesitation.

You will look in vain.

History Becomes Authentic

OR:

THE QUESTION OF THINGS HAPPENING

From:

The Cyclopedia of Classified Dates With An Exhaustive Index
by Charles E. Little
(Compiler of Biblical Lights, and Historical Lights and Side-Lights)
For the Use of Students of History and For All Persons
Who Desire Speedy Access to the Facts and Events,
Which Relate to the Histories of the Various Countries of the World,
From the Earliest Recorded Dates
(New York and London: Funk & Wagnalls Company, 1900)

The Cyclopedia is arranged alphabetically by country, and then each event is listed chronologically in sections such as ARMY/NAVY, ART/ SCIENCE/NATURE, BIRTHS/DEATHS, CHURCH, LETTERS, SOCIETY, STATE, and MISCELLANEOUS. From this massive volume of 1454 pages, I have selected the events that interested me and rearranged them in new sections with my own titles.

The chronicler, who recounts events without distinguishing between the great and small, thereby accounts for the truth, that nothing which has ever happened is to be given as lost to history.

—Walter Benjamin, *On the Concept of History*

Look, there's no sense pretending history is a goddamn Homeric Odyssey.

—Barbara Kingsolver, *The Lacuna*

A Note From The Compiler, Charles E. Little:

THIS BOOK AIMS PRIMARILY to serve as a volume of historical annals for students and general readers, who may desire immediate access to historical facts relating to the persons or events referred to in any publication, or wish to obtain the historical settings of such facts, in the current of simultaneous events. It also aims to serve as a digest of the history of every country in the world; and yet further to show the trend of history almost at a glance.

The labor expended on this work can hardly be estimated by the average reader. The work was begun in 1890, and concluded in December 1899; and from two to five persons have been continuously employed in collecting materials, verifying dates, spellings, and statements, or in critically revising copy and printer's proofs.

Readers are aware that the dates of very ancient history have only an uncertain value. The commonly received chronology has been followed here without indicating any suspicion of uncertainty; but when a point is reached in the

history of a country, after which dates may be accepted as authentic, the fact has been stated in the text.

📖

Let Us Now Praise Famous Men

After devoting his life to virtue and good government, Confucius dies a retired, neglected, and disappointed man. King Theodore of Abyssinia sends an apology to Queen Victoria; he surrenders his captives and makes a present of 1,000 cows and 500 sheep; present rejected; Theodore in despair. Columbus, after long study and much conference with the best authorities, concludes the globe to be only 10 or 12 thousand miles in circumference; he also overestimates the size of the Asiatic continent. The learning and intelligence of Spain admit there is a Fountain of Perpetual Youth somewhere in the Bahamas; Ponce de Leon seeks for it. Unfortunate Balboa is beheaded as a traitor. Cotton Mather, the most learned man in America, dies. Benjamin Franklin assists in producing paper money; (afterwards he perceives its evil tendencies.) Thomas Hutchinson is the most conspicuous man in New England. General Washington enters the city at the head of his army; the whole country is wild with delight. Washington dies at Mount Vernon after a sickness of only one day; universal sorrow prevails. General Hull returns from Canada without attempting anything. George Guess (or Sequoyah), a half-breed Cherokee about 50 years old, invents the Cherokee alphabet. Captain C. F. Hall returns from an Arctic exploration, and reports that he has found many traces of the Franklin expedition, and has discovered that the Esquimaux plundered the members of the Franklin party, and allowed their dogs to feed on the bodies of the victims. John B. Gough decides to devote his life to saving drunkards; he lectures for 75 cents a night; he is later ensnared by a trick of his enemies, and becomes intoxicated. The assassination of President Lincoln enshrouds the country in a gloom like thick darkness. Stanley obtains tidings respecting

Livingstone. Leon, a Mexican, rides 505 miles in 49 hours, 51 ½ minutes, using six mustang horses. George Gilbert, a Youngstown miser, dies; he boasted that his living the year round did not cost him more than three cents a day. Mr. Hughes wins with a score of 558 miles the six days go-as-you-please walking match. Ahmed Shah writes poetry in Afghanistan. Cortez writes his first letter concerning his explorations; Cortez writes a second letter; Cortez writes a third letter; Cortez writes a fourth letter; Cortez writes his fifth letter. Ramses II becomes the father of 59 sons and 60 daughters; (he was probably a polygamist.) Lord Byron swims across the Hellespont. Attila, the chief of the Huns, drinks so freely of honey and water on his wedding-day that he dies of suffocation. Henry IV, the deposed emperor, is forced to sell his boots to obtain food. The Emperor Basil defeats the Bulgarians at the battle of Zetunium; he takes 15,000 prisoners, and destroys the eyes of all but 150, who are permitted to have one eye that they may guide the blind Bulgarians home. Yangti, the second son of Soui, reaches the throne by compelling his brother to strangle himself. Francis Xavier, an intentional missionary to the Chinese, dies on Sancian Island near Macao, after crying out, "Rock, rock, when wilt thou open?" Kwantsong drinks of "the liquor of immortality," by advice of his doctors, and dies. Dr. Thomas Percival is the first to recommend cod-liver oil as a remedy for chronic rheumatism. Patrick Cotter, the Irish giant, is born; he attains the height of 8 feet, 7 inches. Blaise Pascal proves that the atmosphere has weight. Jonas Hanway, the first person to carry an umbrella in London, dies. Blower Brown walks 553 miles in six days, and wins the long distance championship of England. Napoleon makes insolent demands. King Otho becomes hopelessly insane. Arthur Schopenhauer advocates the doctrine of pessimism. Tamerlane builds a pyramid of human skulls. Agha Mahmoud massacres captured people in Karman; 70,000 eyes are brought to him on platters. Thespis of Icaris, the inventor of tragedy, performs *Alcestis* at Athens, and is rewarded with a goat. Noah, a vineyardist, becomes intoxicated. Adam is a horticulturist in Eden. Cain is an agriculturist. Abel is a shepherd.

And A Few Famous Women

Rebecca Nurse, a woman of blameless life, is taken to church in chains, and publicly excommunicated as a witch; later she is hanged. Mary Brush takes out a patent for a corset, the second patent ever issued to a woman. The Bloomer costume, resembling a Turkish jacket and trousers, is introduced by Mrs. Ann Bloomer. Miss Mary Bisland of the *Cosmopolitan Magazine* completes a tour around the world in 75 days and 12 hours, unaided by special conveyances. Two railroad bridges and crossings at Erie are destroyed by a mob of women, who are afterward escorted with banners and music. Miss Susan B. Anthony and 14 other women are prosecuted for illegal voting in Rochester. In a prize-fight in Indianapolis, a woman defeats a man of some local reputation as a pugilist; she gets the stipulated prize of $500. King Louis I marries Judith of Bavaria, who soon gains unbounded ascendancy over her feeble-minded husband. Margaret is divorced from her youthful husband. The Insane Asylum of St. Jean de Dieu at Longue Point, near Montreal, is burned; over 100 of the women patients and several nuns perish in the flames; many insane women escape to the woods. Margaret Davie, a young woman, is boiled to death for poisoning. Elizabeth Croft, a girl of 18 years of age, is secreted in a wall, and, with a whistle made for the purpose, utters many seditious speeches against the queen and the prince, and also against the mass and confession, for which she does penance. Manners are rude: gentlewomen scamper in the streets, turn and stare at passersby, peep into the windows of private houses, and giggle at mass; ladies are told to wipe their lips, not their noses, on the tablecloths, and never to steal or tell willful falsehoods. Sarah Bernhardt is announced to appear in a new Passion Play as the Virgin Mary; (in response to public sentiment, the authorities prohibit the production.) Harlots are by statute required to wear striped hoods of party colors, and their garments wrong side out. Queen Mary's household expenses include 15 shillings given to a yeoman for bringing her a leek. A man sells his wife in the marketplace at Dartmoor, having a rope around her neck as in olden time: her first lover buys her for two guineas.

Ramses II. becomes the father of 59 sons and 60 daughters. [He was probably a polygamist.]

Adam is a horticulturist in Eden.

The assassination of President Lincoln enshrouds the country in a gloom like thick darkness.

LET US NOW PRAISE FAMOUS MEN

Benjamin Franklin assists in introducing paper money.

[Afterwards he perceives its evil tendencies.]

* Columbus, after long study and much conference with the best authorities, concludes the globe to be only ten or twelve thousand miles in circumference; he also overestimates the size of the Asiatic continent.

Napoleon makes insolent demands.

The vestal Cornelia Maximiliana is charged with incontinence, and burned.

AND A FEW FAMOUS WOMEN

Sarah Bernhardt is announced to appear in a new Passion Play as the Virgin Mary. [In response to public sentiment the authorities prohibit the production.]

Susan B. Anthony and 14 other women are prosecuted for illegal voting in Rochester.

The vestal virgin Cornelia Maximiliana is charged with incontinence, and burned. Gail Borden invents a meat biscuit.

The Short Story Of A Small Country

The country is conquered by the Turks. The country is conquered by the Chinese. The country is conquered by the Arabs. The country is conquered by Ismael. The country is subdued by the celebrated Mohammed Shah Kharezin. The country is conquered by Tamerlane. The country is overrun by the Uzbeck Tartars. The country is desolated by a Kirghiz invasion. A new treaty with Russia is published: no foreigner is to be admitted into the country without a Russian passport.

The Short Story Of A Large City

Rome is alarmed. Rome is terrified. Rome is sacked. Rome is recovered. Rome is smitten with pestilence. Rome is burned. Rome is rebuilt. Rome is taken. Rome is restored. Rome is embellished. Rome is besieged. Rome is pillaged. Rome is rebuilt on a grandscale. Rome is visited by a snowfall, the first in 240 years. Rome is supreme.

The Longer Story Of A Raging And Relentless Epidemic

The yellow fever rages. The yellow fever decimates the colonists. The yellow fever appears at Philadelphia, where it commits great ravages. The yellow fever rages. The yellow fever appears in several islands of the West Indies. The yellow fever rages with unparalleled violence. The yellow fever first appears at Havana. The yellow fever is introduced by the slave-trade. The yellow fever rages. The yellow fever again spreads devastation, carrying off several thousand persons. The yellow fever rages, and 700 deaths occur. The yellow fever again appears. The yellow fever rages; 3,645 persons die in Philadelphia, and 2,086 in New York. More than 1,000 deaths from the yellow fever occur in Baltimore. The yellow fever reappears. The yellow fever

Rome is alarmed.

Rome is terrified.

Rome is smitten with **pestilence**.

Rome is besieged.

Rome is taken.

Rome is burned.

Rome is sacked.

Rome is recovered.

Rome is rebuilt.

Rome is rebuilt on a grandscale.

Rome is restored.

Rome is embellished.

Rome is visited by a snowfall, the first in 240 years.

THE SHORT STORY OF A LARGE CITY

Rome is supreme.

rages. The yellow fever prevails in Southern cities; in New Orleans there are 1,200 deaths. Seven hundred people die of the yellow fever in Savannah; 343 houses are left vacant by fugitive owners. Natchez is scourged with the yellow fever; most of the citizens flee. The yellow fever scourges many Southern cities; 7,200 deaths in New Orleans; Vicksburg loses one-sixth of its inhabitants. The yellow fever ravages Norfolk and Portsmouth with great mortality; citizens become refugees. The yellow fever rages again in New Orleans and in the Southwest. The first new case of the yellow fever is reported; about 4,500 deaths follow. The yellow fever appears as an epidemic. The yellow fever rages in the Southern States; 20,000 cases and 7,000 deaths are reported; some of the interior towns in Louisiana are depopulated. The yellow fever rages at Memphis. The yellow fever prevails at Jacksonville; 4,583 cases and 396 deaths are reported. The American schooner *Eva Douglass* lies off the coast with several cases of the yellow fever on board. A yellow fever panic occurs at Pensacola. The inhabitants of Brunswick, except about 5,000, leave from fear of the yellow fever. The yellow fever is raging in virulent form; the death-rate of victims in some places reaches 70 per cent. The yellow fever again prevails. The yellow fever is again prevalent. The yellow fever is again raging. The yellow fever breaks out again. The yellow fever rages. The yellow fever rages. Again. Again.

That Which Prevails

Tranquility prevails along the frontier. A Holy War excitement prevails. Suspicion, dissension, and rascality prevail among the colonists. Poverty, misgovernment, and general distress prevail. Anarchy prevails after the death of the governor. Disputes and bitterness prevail over the arbitrary methods of collecting customs. Great discouragement prevails in the colonies. Great revivals prevail among the Presbyterians. Great public excitement prevails in the election, owing to the number of candidates (four). Great financial prosperity prevails throughout the country. Great agitation prevails over the Wilmot Proviso. A flood prevails in New Orleans; the streets are ten feet under water; plantations are swept by irresistible

currents. Cholera prevails, and many deaths occur. Great distress prevails among the poor. Very cold weather prevails; people cross between New York and Brooklyn on the ice. A lively whisky war prevails. Deep political excitement and solicitude prevail, both in the North and the South. General gloom prevails in the Northern States over the disastrous defeat at Bull Run. Great excitement prevails in the valley of Oil Creek, where a single flowing well yields 3,000 barrels of petroleum oil in a day. Disastrous floods prevail during four weeks of rain; mills, dams, and houses are swept away. Alarm prevails for the safety of Washington. Great bitterness prevails in the South against free suffrage. A great storm prevails; it destroys 384 houses, churches, and many public buildings, besides wrecking eight ships. A blizzard of extraordinary severity prevails along the North Atlantic Coast; many wrecks are made. A hurricane prevails. Cholera morbus prevails. Almost universal bankruptcy prevails, owing to overspeculation in land, building, and other enterprises. Disorders prevail. Great disquietness prevails among the colonists. The black death prevails throughout Austria and all Europe. Great excitement prevails over the military execution of Maximillian in Mexico. Civil war prevails in Bolivia. Polygamy prevails in Central Africa, there being no limit to the number of wives. Famine prevails; human flesh is sold for food. Great excitement against foreigners prevails in Canton. The grippe prevails with severity. A belief in the power of magic prevails. The pestilence prevails. A devastating plague prevails. A state of panic prevails because of the rebellion. The feudal tenure of land prevails. An appalling famine prevails in the Sudan; people are eating dogs, cats, rats, and snakes to keep from starving; hundreds are dying daily. Cholera again prevails. Public excitement prevails, caused by the expectation of the second coming of Christ. The foot and mouth disease prevails among cattle. A terrible tempest prevails. Uncommon mortality prevails. Complete anarchy prevails along the coast. A total eclipse of the sun occurs, and complete darkness prevails. The plague prevails throughout the realm; more people die than have fallen during the continual wars of 15 preceding years. An epidemic, called the "epizootic," prevails among horses in the larger cities, and partially suspends the operation of commerce. General

alarm prevails because of an eclipse of the sun. Excessive heat prevails. Much agitation prevails. Incessant war prevails; the condition of the poor people grows worse and worse. A terrible famine prevails; parents eat their own children. The feudal system prevails. Lawlessness prevails. Constant war prevails. Public agitation prevails. Peace prevails.

That Which Is Prohibited

Laws prohibit many things. Among them, the defrauding of creditors, in order to live in luxury; drinking of healths, as a bad habit; wearing embroidered garments and laces, also sleeves that do not reach the wrist, these must not be more than an ell wide; the use of tobacco by such as are under 20 years of age, those who use it publicly are fined sixpence; all persons are restrained from swimming in the waters on the Sabbath day, or unreasonably walking in the fields or streets. Those who refuse to vote, or serve when elected to office, are fined for want of patriotism. The importation of convicted felons is prohibited. Teaching negroes to write is prohibited. Masquerades and masked balls are prohibited. Authorities forbid chimney-sweeps to cry their trade in the streets. The Legislature passes an Act which imposes a fine on any person who marches in a torchlight parade. The anti-sweater law is vigorously enforced. Placards announce death by burning to persons concealing prohibited books. Duelling by civilians is prohibited. Adulteration of food is prohibited. The police are ordered to ring the town bell at 9 PM daily, and arrest all children under 15 years of age who may be found on the streets after that hour. Otway's *Orphans* is the first theatrical performance in the country, and it is immediately prohibited. The law requires that all officials who drink intoxicants shall be beheaded. A law is made prohibiting any one from selling any hat for above 20 pence, or cap for above 2 shillings, 8 pence. The king prohibits the cultivation of tobacco. An anti-effeminacy act is passed, forbidding men to ride in coaches. A severe statute against sorcerers is passed. Wesleyan preachers prohibit snuff and other indulgences. Calico is prohibited to be printed or worn. Laws prohibit stage plays, making of cards, dice, May-games,

The law requires that all officials who drink intoxicants shall be beheaded.

THAT WHICH IS PROHIBITED

Inoculation is prohibited.

The ancient and popular sport of bear-baiting is prohibited.

Calico is prohibited to be printed or worn.

An anti-effeminacy act is passed, forbidding men to ride in coaches.

*** It is a capital crime to cut down a cherry-tree.**

Masquerades and masked balls are prohibited.

masques, and revels. It is a capital crime to cut down a cherry tree. The exhibiting of the insane at St. Mary at Bethlehem (Bedlam) asylum as a show for money is stopped. The ancient and popular sport of bear-baiting is prohibited. Satirical comedies are prohibited. Inoculation is prohibited. Parliament prohibits the wearing of the Highland dress. Women are prohibited from working in the collieries. The burning of widows is prohibited. The Government prohibits female infanticide. The Government announces that opium-smoking will be prohibited after three years. Private revenge is prohibited in Castile. Comedy is prohibited as libelous. Agapae, or love feasts, are prohibited because of disorderly conduct. Marriage is prohibited in Lent. Philosophers are banished and their works burned; Ben-Habib is condemned to death for philosophizing.

Crime And Punishment

No licensed dealer is to suffer any one to be drunk or to drink excessively (viz., above half a pint at a time), or to tipple above the space of half an hour, or at unreasonable hours (viz., after 9 o'clock.) One convicted of drunkenness three times is accounted a common drunkard. Ministers shall not give themselves to excess in drinking or riot, spending their time idly by day or night, in playing at dice, cards, or other unlawful games. It is enacted that no liquor license shall be granted to any joiner, bricklayer, plasterer, shipwright, silversmith, goldsmith, shoemaker, smith, tailor, tanner, cabinet maker, or cooper, who should be capable of getting a livelihood by honest labor and industry. It is enacted that "The death of a slave from extremity of correction was not accounted a felony; since it cannot be presumed that prepensed malice should induce any man to destroy his own estate." It is decreed that drowning of girl babies by their parents is to be punished by 50 blows of the bamboo. It is enacted that a runaway, or anyone who lived idly for three days, should be brought before two justices of the peace, and marked "V" with a hot iron on the breast, and adjudged the slave of him who bought him for two years. Ninety-seven persons are executed for shoplifting. Obadiah Holmes is whipped; he receives 30 stripes

for being a Baptist; while the blood is flowing, he says, "You have struck me with roses."

Blessed Are The Poor And Hungry

Society punishes the poor: a vagrant a second time convicted is to lose the upper part of the gristle of his right ear; a third time convicted, is to be put to death. Twenty thousand people are starving and destitute; their condition is due to storms. Destitution is announced as worse than last year. Great distress is reported among the unemployed and their families in Brooklyn and New Jersey. Hungry people are flocking to relief-stores. Famine in France produces demoralization; the famine is caused by deranged seasons, and the neglect of tillage by second-advent expectations. Human flesh is sold in the public market; children are decoyed and killed to furnish food for the starving. Corpses are left unburied in the streets because of the great mortality. The unemployed become riotous. Troops of wolves prey upon the smitten people. A famine occurs; it is so dreadful that the people devour the flesh of horses, dogs, cats, and vermin. The working-classes are poor, fretful, and eager for the easing of bondage. A famine occurs; it is so great that bread is made from fern. The people of the drought-blighted counties are starving and in need of clothing. Many associations, soup-kitchens, and plans for visitation are formed to relieve the suffering poor. The State has formally assumed the care of all its insane poor, except those in New York and Kings Counties. An aged couple are driven by poverty to commit suicide. A man in East Twelfth Street, desperate through poverty, kills his mother and himself.

Murder And Mayhem

Jealous over nothing, Marius Guida, a locksmith of La Seyne, killed his wife of 25 years with a billhook.

Curtet is dying in a hospital in Versailles, hit on the head with a pan by the chestnut vendor Vaissette.

Catherine Rosello of Toulon, mother of four, got out of the way of a freight train. She was then run over by a passenger train.

In the vicinity of Noisy-sur-École, M. Louis Delillieau, 70, dropped dead of sunstroke. Quickly his dog Fido ate his head.

With a cheese knife, Coste, from the suburbs of Marseilles, killed his sister who, also a grocer, was his competition.

At 20, M. Julien blew his brains out in the toilet of a hotel in Fontainebleau. Love pains.

<div align="right">--Félix Fénéon, <i>Novels in Three Lines</i> (1906)</div>

Charles G. Corliss is shot dead on the street by a woman, who escapes. A sheriff is shot while sitting in his tent. Antoine Probst is executed for the murder of the Deering family, consisting of eight persons. John W. Hughes is hanged for the murder of Miss Tamzen Parsons at Cleveland. George S. Twitchell is sentenced to be hanged for the murder of Mrs. Mary E. Hill; (he commits suicide). Benjamin Nathan, a wealthy Hebrew, is found murdered in his home; (criminal unknown). C. L. Vallandigham accidentally kills himself with a pistol in a courtroom. Lydia Sherman is convicted of murdering three husbands and eight children. An Advent fanatic assumes to imitate Abraham in offering up Isaac, and sacrifices his sleeping child while the mother looks on. Chastine Cox, a negro, is hanged for the murder of Mrs. Jane D. Hall in New York. An attempt is made to kill O'Donovan Rossa, a Fenian; he is shot in the street by Mrs. Lucille Y. Dudley; she is later acquitted, as insane. Alfred Packer, one of six starving miners in Colorado, having killed and eaten his companions, is convicted of manslaughter and sentenced to 40 years imprisonment. William Kemmler, the first person to suffer the death penalty by electricity, is executed at Auburn Prison for wife-murder. A Chinaman acquitted of the charge of murdering an Indian is dragged from the courtroom at Bridgeport, and cut into pieces by Indians. J. D. Shaw, editor of the Bishopville *Eagle*, is shot dead at a

J. D. Shaw, editor of the Bishopville *Eagle*, is shot dead at a picnic, by two drunken men that he and others were trying to keep in order.

In a fit of melancholia J. B. Hunt kills his wife and shoots himself.

Robert Morrison shoots and mortally wounds his mother at Kingsbridge because she reprimands him for getting drunk.

Henry Karsten, under the influence of drink, compels his wife to drink carbolic acid, and the woman will probably die.

MURDER AND MAYHEM

A tramp murderously assaults a woman after eating a breakfast she gave him; he is under arrest at White Plains.

Lydia Sherman is convicted of murdering three husbands and eight children.

picnic, by two drunken men that he and others were trying to keep in order. A farmer named William Kepke, in Rogers City, near Alpena, confesses having killed two men—16 years ago; he says he is conscience-stricken, and can get no rest. Henry Bushenhagen, aged 69, and his wife Emily, aged 71, are killed in Bloomfield by a tramp to whom they gave shelter; $200 reward is offered for his capture. A tramp murderously assaults a woman after eating a breakfast she gave him; he is under arrest at White Plains. John Carson, a Baltimore lawyer, is found dead in the snow with his throat cut. Near Newark, Patrick Brady, after a drunken bout, beats and kicks his wife to death in the presence of their children. James Freeman, a farmer, murders his wife near Reedsville, because she refused to kill a neighboring farmer. Miss Alice Mitchell, a young society woman, cuts the throat of Miss Freda Ward on the street at Memphis; (adjudged insane). Dr. Robert W. Buchanan is arrested on a charge of poisoning his wife; a week after her burial he went to Halifax, and remarried his (divorced) first wife. A prisoner on trial in the Court of General Sessions is shot dead by the brother of the young girl he had assaulted. W. Mayhor is in jail at Sidney, charged with murdering five wives. C. J. Johnson is convicted of manslaughter in the first degree for throwing his wife out of an upper window and killing her while he himself was drunk. Matthew Green kicks James Halstead till he causes his death. F. Howlock mortally wounds his sweetheart and then commits suicide in Brooklyn; cause, jealousy. S. G. Southard of Pittsburg shoots his wife and kills himself because he objected to his children being educated as Catholics. Mrs. Catharine Fitzgerald shoots and kills Mrs. Carrie Pearsall on Eighth Avenue, and then gives herself up to the police. Daniel O'Neil, while drunk, pours kerosene over his baby's cradle and tries to burn the child; he then beats his wife for trying to prevent him. Mrs. Augusta Schneider, a wealthy lady, quarrels with one of her tenants, and shoots and kills him near Walton. Henry Karsten, under the influence of drink, compels his wife to drink carbolic acid, and the woman will probably die. Robert Morrison shoots and mortally wounds his mother at Kingsbridge because she reprimands him for getting drunk. Albert Johnson shoots his sweetheart, Carrie Andrews, and kills himself, on account of breaking of

her engagement. At Johnstown four masked men break into the house of a widow 84 years old, string her up until nearly insensible, burn her feet, rip off her clothes, and subject her to other indignities; they secure only 70 cents. Lillian Willis kills her father during a family quarrel at Homer; the jury acquits the girl because of its being done to save her mother's life. A young woman is killed in the street in Cincinnati by Father D. O'Grady, a jealous Roman Catholic priest. Barney Sacks, a confectioner, shoots his mother and kills himself. Adolph Brenner, an anarchist, makes an attempt to murder an entire family in Brooklyn; he lodges a bullet in his own head. In a fit of melancholia J. B. Hunt kills his wife and shoots himself. Seven lives are sacrificed by a drunken husband and father at Chaska by driving his team into the river. E. P. Hilliard, a lawyer, is killed in his office by E. C. Hastings, a milkman. The murder of Mr. Briggs in a first-class carriage on the North London railway causes great excitement. A woman's body, stabbed in the breast, and covered with chloride of lime, is found in the house occupied by Mr. Henriques, in Harley Street. Monsieur Habert kills Monsieur Felix Dupuis, an artist, in resentment for satirical verses.

Weather And Other Wonders Which Mother Nature Hath Wrought

A fearful storm attended by an earthquake nearly destroys the fleet. The crops are almost entirely destroyed by locusts. Several villages are destroyed by an earthquake; a prolonged drought and famine follow. The cholera destroys 50,000 persons. Reported death of 61 persons killed by a waterspout. A plague of grasshoppers damages the growing crops. A destructive hailstorm visits Baltimore; 20,000 panes of glass are broken. Another plague of locusts. Swarms of crickets devastate vegetation in many localities. A forest fire destroys 35,000 acres of trees; locusts destroy the pastures. Terrible storm and great tide 20 feet high; lives and property destroyed. An earthquake alarms the people. A great comet becomes visible; it terrorizes New England, while it enables Newton to ascertain the parabolic form of the trajectory of comets. Snow is six feet deep. An alarming earthquake occurs; 18,000 persons are buried in ruins; every inhabitant but one is

destroyed by the earthquake or the tidal wave attending it. An earthquake swallows up 80,000 inhabitants. On the coldest day in 25 years, ice is 17 inches thick, an ox is roasted on the river. An extraordinary and brilliant meteor is seen; it explodes three times. A spot on the sun is visible to the naked eye for several days. An aurora borealis of surpassing grandeur is observed. Frost appears at Pittsfield—the mercury stood at 90° during the previous day. A great snowstorm begins and continues 36 hours; it block-ades the New England roads. A tornado half a mile wide nearly destroys the town of Brandon. The most violent snowstorm in 23 years prevails from Washington northward. A terrible gale at Albany unroofs 50 houses; many chimneys and walls are blown down. A great flood sweeps the Connecticut valley; the river is 29 ½ feet above low-water mark. A prostrating destruc-tive cyclone visits Manteno. The Lackawanna Valley is invaded by millions of locusts that settle on every green thing. Rivers rise 47 feet after three days of rain. A brilliant meteor passes over Chicago, looking like a ball of fire with a broad trail of light in its wake, and emitting a hissing sound. An earthquake disturbs the people at Toledo. A plague of caterpillars infests the town of Burke; they are devouring herbage in a track nearly a mile in width. A great earthquake and tidal wave occur at the mouth of the Colorado River, accompanied by wonderful phenomena; the whole region is stirred by hundreds of mud volcanoes and sulphur eruptions. Large num-bers of crickets are moving from northern Idaho south and east, destroying fruit and grain on their way, to the utter dismay of the farmers. An ava-lanche buries a train near Klagenfurth, Carinthia. At Triest, Carniola, an engine freezes fast to the rails; traffic is suspended. Snow is six feet deep. A strange darkness occurs about 2 PM, continuing about 40 minutes, and afterward is repeated, but of less duration. Fifteen craters, throwing out masses of mud, in a Chilean valley, carry ruin in every direction, and sweep away houses, cattle, and people. An earthquake destroys the entire country between Santa Fé and Panama; 40,000 persons in the cities of Cuzco and Quito are killed in one second. Swarms of locusts die, putrefy, and occasion great mortality. A morning comet shaped like a fiery pillar is seen for three months. Continuous frost prevails; oxen are roasted and bulls are baited

During a shower at Cairo a number of live fish, four inches in length, fall in various parts of the city.

A plague of frogs visits Little Falls.

A total eclipse occurs; the darkness is so intense that the stars can be seen, and the birds roost at noon.

An extraordinary plague of fleas occurs; they cover the clothes of the people.

Snow is six feet deep.

Lightning strikes the Eiffel Tower without injuring it.

on the ice-covered Thames. The forest-trees, and even the oaks in England, are split by the frost: most of the hollies are killed. An extraordinary plague of fleas occurs; they cover the clothes of the people. A total eclipse occurs; the darkness is so intense that the stars can be seen, and the birds roost at noon. A brilliant comet appears; it passes with great swiftness, and within 2,000,000 miles of the earth; its tail forms an arch 36,000,000 miles long. Ice is seven feet thick on the Black Sea; it is frozen over for 20 days. Swarms of locusts darken the air, and breed pestilence from their putrid bodies. Lightning strikes the Eiffel Tower without injuring it. A big landslide occurs on Second Avenue at Pittsburg. Gelatinous matter falls from the sky soon after the passage of a brilliant meteor. Red snow and hail with red dust fall in Tuscany. Honeydew falls near Raithiermuc; it is gathered with scoops. A shower of greasy matter falls; it becomes offensively odorous when drying. A plague of frogs visits Little Falls. Dew resembling butter in its consistency and color is formed in many places; it falls frequently in low places, and sometimes remains a fortnight. A shower of snails occurs at Tiffin. A shower of frogs occurs at Jamestown. During a shower at Cairo a number of live fish, four inches in length, fall in various parts of the city. On January 8, 1890, a large spray of cherry-blossoms is picked from a tree at Nyack-on-the-Hudson, New York State.

A Handful Of Ethnographical Observations

Hottentots are but slightly civilized, and preserve tribal relations in the remote western sections where they abound. Bushmen are a diminutive people of light yellowish-brown complexion. The Bechuanas are a people of fine physique, which is maintained by getting rid of the feeble and sickly. The half-castes are called Griquas, and are active, vigorous, enterprising, and courageous, and much superior to the aborigines. The Zulus believe in witchcraft, demons, and ancestral spirits. Libyans having fair hair and blue eyes invade the desert west of the Delta; sacrilege becomes fashionable; the grossest social indecency is manifested. The arts of the Gauls are chiefly those that minister to their vanity; they are of large stature, fair complexion,

usually having yellow hair and fierce mustaches. Among the great of France, all pretense to morality, religion, and decency is abandoned; a dissolute frivolity and superciliousness are commonly affected; ladies married and single indulge in the most indecent jokes, and swear profane oaths in nearly every sentence. The ancient Germans have fair hair and blue eyes; they are taller than the Romans, and seem to them as giants; they honor chastity in women as they do bravery in men; they are, above all, distinguished by a strong sense of personal independence; in their faithfulness, courage, and personal purity they are emphatically contrasted with other barbarous peoples. The Saxons are energetic, aggressive, and practical; they love their homes. In Poland the custom of killing old men when unable to labor, and such children as are born imperfect, is practiced. The Icelandic people are remarkable for their moral qualities. The aborigines of America speak from 400 to 500 different languages, vary in size from the semi-dwarf of the Arctic regions to the Patagonian giants of the South, and embrace a variety of shades of brown in their color; they cultivate the soil and produce maize, beans, pumpkins, and tobacco; the universal vice is indolence. The Aztec language is copious and polished; some of its words have 12 or 15 syllables. In Mexico, religion is savage in spirit and more degrading than that of the uncivilized Indians, their deities being hideous creatures to whom human sacrifices are yearly offered in great numbers. The Incas are regarded as a sacred race, possessing divinity derived from the great deity, the sun; sacrifices are chiefly edible fruits or grain, and are always bloodless. Peruvians far surpass the Mexicans in both the practical and elegant arts of life; they excel in masonry, using hard chisels, and they ornament their work with carvings. Chileans are a brave-spirited people, without ferocity; they are the most manly and energetic of all Americans.

Our Home And Native Land

Canada is entirely evacuated by the Americans, "defeated, discontented, dispirited, diseased." A remarkable earthquake occurs in Canada; it continues at intervals for more than six months; mountains and rivers disappear,

and new lakes are formed. Quebec and all Canada are reduced by the English. Joyful *Te Deums* are sung in the churches on the accession of Queen Victoria; but in Lower Canada the French Canadians walk out of church during the singing. A constitutional crisis occurs. The splendid Parliament House at Quebec is burned with valuable philosophical apparatus. A man named Whelan, convicted of the murder of Thomas D'Arcy McGee, is executed. "Jack the Ripper" is said to be in jail in Halifax; he is a medical student; information given by his sister was the cause of his arrest. Two pilots and three others report seeing a sea-serpent, 200 feet long, off the Richibucto shore; it has a flat-shaped head, with eyes on the top like a frog, and in body about as thick as a man. Master Wolfall, an Englishman, celebrates communion on the shores of Frobisher Strait, the first communion recorded in America. Indians on the east coast of Lake Winnipeg are attacked by starving wolves. The thermometer registers 40 degrees below zero near Ottawa. The Parliament is prorogued.

A Brief Miscellany Of Mysteries And Marvels

1770 B.C., *China:* Kia, the tyrant, is a voluptuary. To gratify his favorite concubine, he provides "her with a splendid palace, and in the park that surrounded it a lake of wine was formed at which three thousand men drank at the sound of a drum, while the trees hung with dried meats, and hills of flesh were piled up."

600 B.C., *Chaldea*: A chart of the heavens is made, in which 1,460 stars are correctly described.

265 B.C., *Roman Empire*: The solar year is found to comprise 365 days, 5 hours, 48 minutes, 51 seconds, and 6 decimals.

800 A.D., *Arabia*: The first apothecary's shop in the world is established at Baghdad.

1291, *France*: The Crusades have unexpected, valuable, and far-reaching results. The spirit of adventure is stimulated, literature is revived, the arts and sciences promoted, and free thought and liberal ideas are increased in the world. The Crusades awaken the intellect and arouse the genius of the people.

1303, *Egypt*: Christians are compelled to wear blue turbans, and Jews to wear yellow, and both are forbidden to ride on horses or mules, or to receive any government employment.

1348, *France*: The people are smitten with the Plague of Florence, or the Black Vomit; the ignorant people accuse the Jews of poisoning the waters, and destroy thousands of them.

1393, *Hungary*: The female sovereign is called King because of an aversion to the name Queen.

1462, *Great Britain*: The people wear the beaks or points of their shoes so long that they encumber themselves in walking, and are forced to tie them up to their knees; the fine gentlemen fasten theirs with chains of silver, and others with laces.

1483, *France*: Transfusion of blood begins to be practiced for the purposes of prolonging life; Louis XI, when dying, drinks the warm blood of infants.

1507, *Mexico*: To mark the beginning of a new cycle of years, fire is kindled for the last time on a human breast in Mexico.

1621, *United States*: The first duel in New England brings disgrace on the duelists; it is fought by two servants with sword and dagger, and both are wounded; the authorities sentence them to lie 24 hours with their heads and feet tied together.

1649, *London*: Sixty houses in Tower Street are destroyed by an explosion; a child in its cradle lands unhurt on the roof of Barking Church.

1675, *Massachusetts*: The colonists are terrified by an impending Indian war. Superstition adds it terrors; some have seen an Indian bow drawn across the heavens; others see a scalp on the face of the eclipsed moon; others see phantom horsemen gallop through the air, or hear the whistling of bullets, etc.

1750, *London*: During some trials in the Old Bailey court, the lord mayor, one alderman, two judges, the greater part of the jury, and numbers of spectators, catch the jail distemper, and die.

1753, *Europe*: It is commonly believed, even by educated people, in the Old World, that plants and animals degenerate in size and quality when transplanted into the New World.

1765, *Great Britain*: The peruke-makers petition the king for redress because the people are wearing their own hair.

1820, *Great Britain*: The Fairlop Oak, having a trunk 48 feet in circumference, the growth of five centuries, in Hainault forest, Essex, is blown down.

1820, *Italy*: A Frenchman commits suicide by throwing himself into the crater of Vesuvius.

1851, *New York*: A catastrophe in a schoolhouse occurs because of a panic on an alarm of fire; the banisters give way, and 43 scholars are killed.

1868, *Abyssinia*: Report of animals used in the British expedition: 45 elephants, 7,417 camels, 12,920 mules and ponies, 7,033 bullocks, 827 donkeys.

600± * * B. C. *Chaldea.* A chart of the heavens is made, in which 1,460 stars are correctly described.

Three hundred persons are poisoned by eating ice-cream at the high-school reception at Rochester.

A BRIEF MISCELLANY OF MYSTERIES AND MARVELS

1893

ABYSSINIA.

* Report of animals used by the British in the expedition : 45 elephants, 7,417 camels, 12,920 mules and ponies, 7,033 bullocks, 827 donkeys.

1868

6

1393 * * *Hung.* The female sovereign is called King because of an aversion to the name Queen.

1891

1890

GREAT BRITAIN

The bones of a hippopotamus are found embedded in clay.

Asbury Park and Ocean Grove have a baby parade, which is two hours in passing.

1880, *United States*: The census returns show that 5,107,993 white and colored persons, aged 15 years and upward, are unable to write.

1890, *Great Britain*: The bones of a hippopotamus are found embedded in clay.

1891, *New Jersey*: Asbury Park and Ocean Grove have a baby parade, which is two hours in passing; in the presence of an immense multitude, there are 500 babies in the line of carriages.

1893, *New York*: Three hundred persons are poisoned by eating ice-cream at the high-school reception at Rochester.

1893, *Illinois*: The trotting mare Nancy Hanks makes a record of one mile in 2.08 minutes at Springfield.

1894, *Austria*: Seven cave-explorers are imprisoned by floods at Luglock, Gratz; eleven days later they are rescued; all are alive, but one woman is insane.

An Exhaustive Index
A Note From The Compiler, Charles E. Little:

This exhaustive index (of 291 pages) has been prepared with uncommon fullness of detail, so as to aid those persons who may turn in haste to find desired information; also to give necessary information to those having none of the clews which a general historical knowledge afford. But it is anticipated that many readers who are familiar with the general trend of the history will commonly ignore the index altogether and turn at once to the text. The index also contains some items which were omitted from the text.

Abed-nego, fiery furnace. Accordion, invented. Adultery, punished with death. Air-ship, new, exhibited; it does not work. Alchemists, forbidden.

Amazons, conquered. Appo, George, throat of, cut. Ark, begun by Noah. Army worm, in Wisconsin. *August Flower*, lost. Aurora borealis display, alarming. Avarice, abounds.

Ballads, popular among lower classes. Balloons, bring favorable intelligence. Barbers and surgeons, unite. Baseball, curve pitching introduced. *Bavaria*, infernal machine in. Bayonet, invented. Beer-brewing, is known. Bees, introduced. Beethoven, becomes deaf. Beggars, abound. Bells, introduced. Blacksmiths, hereditary sorcerers. Bohemian brothers, banished. Bon, Mayer, a Jew, burned. Borden, Lizzie, acquitted. *Brazen*, wrecked. Breastplates, introduced by Jason. Brigands, abound. Bruce, makes second visit. *Bruiser*, collides. Buccaneers, great depredations of. Bullets, as currency.

Caesar, Julius, in conspiracy; indebtedness; conquers Gauls, etc.; invades Britain; alienated from Pompey; works; crosses Rubicon; supreme ruler; fires Egyptian fleet; declared enemy; marches toward Rome; abdicates; triumphs; corrects calendar; assassinated. Cain, offers fruit as sacrifice. California, becomes part of Mexico. Caligula, murdered. Cambodia, a vast and important country; swarms with foreign adventurers. Cappadocia, subdued; conquered; ravaged; surrendered; annexed; recovered. Carriages, introduction of, excitement attends. Cattle, become acclimated. Cherokees, 16,000, cruel and iniquitous removal of, greedy white men want their land. Chicago, yet a frontier town. Children, cruelty to, bill. Chocolate, Spaniards bring from Mexico. Circular saw, invented. Circumcision, rite instituted. Civilization, appears arrested. Cocaine, as anesthetic. Coffee, introduced. Colossus, thrown down; broken. Concertina, invented. Confinement, gentle, party held in. Constantine, pope, introduces kissing of pope's toe. Convicts, kindly treated. Corday, Charlotte, heroine, guillotined. Corruption, official, period of. Cowboys and Indians, fight between, still going on. Curfew bell, rings. Czarina, insane.

Death, hangs on the frontier. Decimal system, invented; adoption defeated. Degrees, measured. Desperado, holds up train, shoots several. Diet, imperial, held at Worms. Dinghein, Mrs., linen starching. Disorders, great, occur in Persia. Dissection, of human body, by Vesalius. Divorce suits, courts busy with. Dog, mad, 14 persons bitten. Domestic comforts, introduced. *Don Quixote*, by Cervantes, appears at Madrid. Drought, long, broken. Dust and disease, controversy. Dutch, attempt to enter China; again repulsed.

Earth, centre of universe. Eclipses, theory of, is known. Elephant, mad, much damage near Providence. Eskimos, appear; distress settlers. Etiquette, forms of, extremely majestic, but cumbrous. Euhrussi, M., wins lottery prize. Eunuchs, intrigue.

Fabrigio, discovers vein valves. Family, is instituted. Field, Mr., stabbed. Fire-annihilator, invented. Flagellants, conspicuous. Flour, high price of, riot occasioned by. Fools, England, law for natural. Forgery, punishable by death. France, begins intercourse. Frauds, election, astounding. French, triumphant, everywhere. Friendless, State Home for the, opened at Lincoln. Fustians and jeans, manufacture begins.

Garden, botanical, begun. Giants, skeletons of, discovered. Girondists, conspicuous; in power; fall of; beheaded. Gladness, a tumult of. Gold-diggers, great influx of. Goldfish, brought to England, from China. Goose, riot over ownership of. Gossips, arrested, in Austria. Gould, Helen, arrest for annoying. Guessing contests, legal. Gun, Gatling, patented.

Hanging in chains, abolished. Harlots, punished. *Harvest Moon*, blown up. Heat oppressive, many people prostrated. Helen-Judith, joined twins, born. Hesione, freed from monster. Hicks, Mrs. (witch), hanged. History, becomes authentic. *Hope*, captured. Horrors, abound. Hours, eight, a day's work. Hoy family, murdered. Hungary, overrun by Poles. Hunstville, Alabama, surprised. Husbandry, first taught. Hydrogen gas, lighter than atmosphere.

Ignorance, abounds. *Impregnable*, wrecked. Incest, not uncommon. Independence, feeble attempt made for. Indians, American, baptized; burned; subdued; cruelty to family; attack settlers; warning of; pestilence decimates; defrauded; treaty of peace; truce; troubles; converted; attacked; ravaged; annihilated; routed; chiefs killed; hostilities; massacres; abused; war impending; oppression of; peace with; depredations of; bounty for scalps; expelled; peaceable; worship sun; traitors; mutinous; war against; persecuted; civilized; surprised; ghost dances; arms against; rise; surrender; on war-path; disagreement about land; reservation ceded; reservation withheld; disturbance against cowboys; sun dance forbidden; responsible for all crimes; Improved Order of Red Men, founded. Infidels, multiply. *Inflexible*, launched. Irene, marriage proposal; regent; imprisoned; rules; reigns alone; dethroned; deposed; murdered. Iron, art of welding, discovered.

Jacobins, have everything their own way. Jesus, the Christ, birth at Bethlehem four years before the vulgar era; performs first miracle, water into wine; heals a leper; cures a withered hand; restores a demoniac and is slandered; teaches the multitudes; stills the tempest on the sea; feeds the 5,000; walks on water: predicts his passion; provides a sacred half-shekel from a fish's mouth; pardons an adulteress; defines love to one's neighbor for a lawyer; restores Lazarus; eats his last Passover; retires to the Mount of Olives; crucified; risen. Jews, permitted to study law. Jezebel, killed. Jonathan, defeats Joel, bloody battle. Jumbo, elephant, arrives from London. Jupiter, is known.

Kaleidoscope, suggested. Kane, Mr., shot. Kelly, Mike, lynched. Kelly, Ned, captured. Kelly, Timothy, convicted; executed. Kettles, brass, made. Kings, petty, rule. Kleph, killed. Koelxler, F., suicide. Kraft, Joseph, child kidnapped.

Lace, very delicate, made in Flanders. Laws, code of, digested. Leprosy, case of, at Chester. Liberty, trees of, planted. Licentiousness, abounds. Life, is held cheaply. Literature, encouraged; grows in repute as profession.

AN EXHAUSTIVE INDEX

Hope, captured.

Goldfish, brought to England, from China.

8

Gould, Helen,

Jupiter, is known.

arrest for annoying.

Indians, American, responsible for all crimes.

Logarithms, invented. Lothaire and Louis, rebellious princes, beg for mercy. Lover disappointed, kills six and self.

Ma, assassinated. Machinery, prohibited in prisons. Mammoth, flesh and bones intact, discovered. Manhood suffrage, introduced. Marah, bitter waters. Margary, Mr., killed. Marriage, Irregular, Act, passes. Marriages, with lunatics, made void. Martin, makes papier-maché. Mason, Mabel, life-saving medal. Massacre: See *Indians*; See *Slaughter*. Maundas, Laura, horse-thief. Maurice, hanged for piracy. McCabe, robber, hanged. Meat, extract of, invented. Meshach, fiery furnace. Millie-Christine, joined negro twins, born. Miracles, multiply. Mongols, are supreme. Monkeys, kept as pets. Moon, map of, first drawn. Morality, of clergy, at lowest ebb. Mormon, elder, tarred and feathered. Morrison, J. G. W., stoned to death. Mortality, extreme. Mortality, very great. Mortality, very unusual. Mulberry trees, many planted. Murders and outrages, continue. Mythical Period: See *Revolt of the Titans*; See *War of the Giants*.

Nails, wrought. Nancy, is acquired. Naomi, dwells with Ruth. National felicity, golden age of, enjoyed. National Thrift Society, founded. National Trade Society, founded. National Truss Society, founded. Nebuchadnezzar, troubled by a dream. Negro school, difficulty. Neilson, Mr., murdered. Nevins, Miss, marriage of. *North America*, sunk. *North Star*, seized. Number, the golden, discovered.

O'Brien, Thomas, escapes from keeper. *Ocean Wave*, burns; collides; explodes. Odometers, improved. Oedipus, myth of; answers riddle. Olga, baptized. *Olga*, wrecked. *Ophelia*, asteroid, discovered. *Oregon*, explodes. Oysters, scarce.

Paganism, merits discussed. Painter, Thomas, whipped. Paper, endless, invented by Robert. Paris, carries off Helen. Parsons, Lucy, anarchist, arrested. *Pauline*, captured. *Peacemaker*, explodes. Pelicans, two, appear.

AN EXHAUSTIVE INDEX

Poland, blotted from map.

Parsons, Lucy,

anarchist, arrested.

Pelicans, two, appear.

Quoits, game of.

Pig,

shooting of,

raises question of territorial rights.

Period, darkest, disorders abound. Persons, only a few, spared. Petroleum, found; excitement ensues. Phillbroke, Mary, rejected. Pig, shooting of, raises question of territorial rights. Pillory, used for last time. Pixley, Mr., obtains prize. Poland, blotted from map. Politics, no purity in. Polka dance, introduced, attracts great crowds. Pomeranians, on shores. Populace, is brutal. Potato, discovered. Potato-bug, discovered. Primogeniture, abolished. Princes, pagan, rule. Profligacy, abounds. Pyramids, placed with astronomical exactness.

Quoits, game of.

Racehorse, lost. Rankin, John, walks to London. Ranters, appear. Rarey, John S., horse trainer, receives present. Relief, indescribable feeling of. *Resistance*, blown up. *Resolution*, wrecked. Robbery, highway, frequent. Robin Hood, legendary robber, flourishes. Roman army, saved from Quadi, miracle.

Samson, first Jewish suicide. Scalawags, nicknamed. Scrofula, cured, by king's touch. Seamless hose, manufactured. Shadrach, fiery furnace. Shoemakers, riot of, suppressed by army. Shoes, India-rubber, first seen in America. Sickness, sweating, afflicts North Germany. Simony, universally practiced. Sing Sing, prison, commenced. Snowstorm, 7,000 soldiers perish. Snyde, Sicke, beheaded. Sontag, outlaw, wounded. Spanish marriages, cause trouble. Squirrels, gray, doing immense damage. State prison, made an insane asylum. Stephen, dies. Stereotypes, increased durability of. Stuart, Lady, fined for playing faro. Suppression of Vice, Society for the, incorporated. *Swallow*, launched. *Swamp Angel*, bursts. Szil, crushed to death in wine-press.

Taxes, laid on billiards, playing cards, hair-powder. Teeth, false, from minerals, manufacture of, commenced. Terry, Kate, last appearance as Juliet. Tesch, shoots at king. Theology, medicine, law, and arts, suppressed. Thermometer, invented. Thimbles, made of gold. Thundering Legion, escapes. Tides, explained. Timothy, stoned. Tip, elephant, killed. Tongues, confusion of,

AN EXHAUSTIVE INDEX

Tongues, confusion of, at the Tower of Babel.

10

Teeth, false, from minerals, manufacture of, commenced.

Vick, makes a clock.

Umbrellas, scouted as evidences of effeminacy.

Whales, three, stranded.

Violins, introduced.

at the Tower of Babel. Trial by combat, forbidden. Trial by jury, abolished. Trial by ordeal, abolished. Trial by torture, abolished. Trousers, loose, introduced. Two Sicilies, conquered. Tyrrel, Walter, shoots king.

Ultramarine, is known. Umbrellas, scouted as evidences of effeminacy. Universal joy, abounds. Ursula, died. Usury, prohibited, England; allowed to Christians, Italy. *Utopia*, sinks. Uzzah, is smitten.

Velocipedes, become common. Venice, mistress of the seas. Ventriloquism, described. Verdi, Guiseppe, writes many operas. Vesovici family, murdered. Viciousness, brings about dearth. Vick, makes a clock. Violins, introduced. Virginia, stabbed in forum, by father. Vulcan, planet, discovered.

Waiters, strike of, in full force. Walker, makes ice. Wall, is built. Webb, Matthew, swims English channel; drowned. Whales, three, stranded. Wilson, Catherine, executed. Window, glazing, common. Windsor, Ontario, opium smugglers. Winter, severe, Flanders; the wine is frozen solid; must be cut by hatchets. Witches, becoming difficult to convict. Working classes, restless. Wretchedness, abounds. Wright, Austin J., pork conspiracy. Wright, Patience, models miniature heads, wax.

Xanthippe, asteroid, discovered. Xanthus, taken. Xenia, Grand Duchess, marries.

"Yankee Doodle," sung. *Yazoo*, sinks. Yokohama, an insignificant fishing-place. York, Patrick, hired to kill queen. Youth, Feeble-Minded, School for, opened.

Zabzalians, sect arises. Zama, Africa; Hannibal's army annihilated. Zanzibar, Stanley arrives at. Zenji, Isono, "mother of drama," flourishes. Zion, Mormons found. Zirconium, discovered. Zodiac, observed. Zwornik, surrender of.

Consumptives Should Not Kiss Other People:

One can preserve fruit by sealing it in jars.

Sun shine makes the world happy and gay.

Tight clothing of any kind we should always avoid.

But a cold bath should never be taken in a cold bath room.

A HANDY GUIDE TO THE CARE AND MAINTENANCE
OF YOUR FAMILY'S GOOD HEALTH

From:

The Ontario Public School Hygiene
by A. P. Knight, M.A., M.D., F.R.S.C.
(Professor of Physiology, Queen's University, Kingston)
Authorized by The Minister of Education by Ontario
(Toronto: The Copp Clark Company, 1920)

and

Ontario Public School Health Book
by Donald T. Fraser, M.C., B.A., M.B., D.P.H.
(Assistant Professor, Hygiene and Preventive Medicine,
University of Toronto)
and
George D. Porter, M.B.
(Director of Health Service, University of Toronto)
Authorized by The Minister of Education
(Toronto: The Copp Clark Company, 1925)

Just as there is no royal road to learning, so there is no magic key which will open the Temple of Health. The best we can do is to rely upon good habits, in order that we may acquire and maintain good health. If you keep your eyes open to many facts that are about you, you will not find it difficult to understand.

—*The Ontario Public School Hygiene*

YOU HAVE ALL FELT YOUR HEARTS BEAT.[*] The amount of work done in twenty-four hours by the heart of a person living under usual conditions is enough to lift that person to about twice the height of the highest sky-scraper in the world. To assist the heart and to keep it healthy and strong, there is need of good food, regular exercise, sufficient rest, and fresh air.

Generally speaking, the air of the country is rarely spoiled. It is different, however, in cities and towns, especially those in which there is much street traffic and where many shops and factories burn coal.

Air is also impaired by tobacco smoke, by the odour of burnt food, by decaying garbage, by filthy outbuildings and yards, by bad cellars and drains, by disagreeable odours, especially from the feet of people who do not bathe frequently, and by odours from the clothing, bedding, or floors and walls of houses that are not kept clean.[†]

In some American states, school trustees are required to provide each child with at least 1,800 cubic feet of fresh air an hour, and this is very desirable in the interests of the health of the children.

[*] What is meant by a heart beat?

[†] Ammonia is another substance which is always present in air. Boys and girls who have happened to go near a fresh manure heap must sometimes have recognized the peculiar odour of this gas.

Dr. Leonard Erskine Hill once placed eight students in a box about 120 inches long by 40 inches wide and 40 inches deep, and sealed it up tight so that no air could enter or leave it. "At the end of half-an-hour," he tells us, "they had ceased laughing and joking and their faces were congested."

Perhaps one of the most terrible instances of bad air was seen in the prison known as the Black Hole of Calcutta. One hundred and forty-six persons were shut up over night in a cell twenty feet square provided with no means of ventilation except two small windows. So poisonous did the air become that one hundred and twenty-three died during the night.

The fact that some occupations are less healthful than others, just because of bad air, seems to be borne out by the high death-rate among barbers, hairdressers, dressmakers, seamstresses, school teachers, printers, and pressmen.[*]

It is generally believed that the high death-rate which prevails in small houses is due to lack of fresh air, but the truth is that other causes, such as lack of clothing, lack of proper food, bodily weakness, and especially the ease with which disease germs spread from person to person in crowded rooms, help to produce the high death-rate.

📖

What sort of house should we live in? Should it be large or small? Should it be built of stone, brick, wood, or concrete? Should it be located upon a hill or in a hollow? Should a low rental be the chief consideration, or should the house be chosen because it is sanitary?

Note again the much lower death-rate—only 3.3 per cent—among the inmates of those homes which have five rooms and upwards. Having fixed upon the minimum size—and no family however poor should live in a smaller one—let us consider some of the other requisites of a sanitary house.

The windows should be large in proportion to the size of the house, so that sunshine may flood every room, killing microbes and aiding in the

[*] Unfortunately for us, we are not able to grow new lungs whenever we need them.

You have all felt your hearts beat.

Perhaps one of the most terrible instances of bad air was seen in the prison known as the Black Hole of Calcutta.

What is meant by a heart beat?

Some people seem to be afraid of night air; they should remember that night air is as good as the air in the daytime.

What sort of house should we live in?

production of good red blood in those inmates who are compelled to live all day in the house.

The bedrooms should open upon sleeping porches by means of either French windows or Dutch doors. Every consumptive, and in fact all other members of the family, would be benefited by sleeping on the porches throughout the year. On the approach of winter the beds should be withdrawn from the sleeping porches during the day into a warm bedroom. At bed-time, patient and bed should be rolled out on to the sleeping porch and should remain there all night.*

Fresh air makes one sleep more soundly and prevents the headaches which so frequently attack those who sleep in close, stuffy bedrooms. Some people seem to be afraid of night air; they should remember that night air is as good as the air in the daytime.†

The greatest care should be taken to furnish a house simply. Hardwood chairs and tables are all that are necessary for the kitchen and living room. Single iron bedsteads should be the rule. Folding beds or sofa-beds are objectionable on hygienic grounds. The furnishings of a house should be such as to throw as little labour as possible upon the housekeeper. When floors are buried under carpets, when windows are hidden with lace curtains, and walls are covered with paper, it is very difficult to keep a house clean, and a dirty house is an insanitary house.

A house which will not promote the health of every one of its inmates should be pulled down.

📖

Dissipation, loss of sleep, worry, poor or scanty food, lack of exercise, excesses of all kinds, and badly ventilated houses all tend to increase the

* Of course, the bed-clothes must be adequate. The head also must be protected by a cap warm enough to prevent the sleeper from catching cold. In the morning the occupant returns to the warm bedroom, where the dressing is done.

† The value of sufficient sleep cannot be overrated. Children who do not have enough sleep become irritable, pale, and delicate. Sleep is a mysterious and wonderful thing.

number of cases of pneumonia, colds, and influenza, whenever exposure to the germs of these diseases occur.*

Some people are more liable to catch cold than others. Either they are naturally weak and delicate, or they have made themselves soft by wearing too much clothing. People who remain much in over-heated houses in winter or who always wash the face and throat in warm or lukewarm water, are also very liable to catch cold.†

The practice of having a number of pens and lead-pencils kept in a box and passed round to pupils from day to day is wrong; because some pupils have the habit of holding these articles in the mouth, and they may be the carriers of such diseases as diphtheria, measles, scarlet fever, mumps, whooping-cough, pneumonia, influenza, common cold, tuberculosis, or cerebro-spinal fever.

Ugly as the fact is, it is nevertheless true, that every case of typhoid fever means the transfer of germs, either directly or indirectly, from the excreta of one individual to the mouth of another. A typhoid epidemic, therefore, is a reproach to the intelligence and moral sense of a community.

There is a very dangerous and ever-threatening enemy against which we must defend ourselves. This enemy is so strong and does so much harm that every one should know of his wiles and how they may be combated. This enemy is called tuberculosis.

The most important step to be taken in controlling an outbreak of diphtheria is to isolate not only the sick, but also the carriers. This is easily done in institutions like jails, asylums, hospitals, or residential schools, but it is a more difficult procedure when the outbreak occurs among the community at large.

A law has been made requiring a notice to be posted beside the door of every house in which there is a communicable disease. In compliance

* Hundreds of lives can be saved if the doctor is called in at once in every case of a bad sore throat. This cannot be over emphasized.

† It is perhaps necessary to explain in this connection that no one ever catches a cold from a draught.

This enemy is called tuberculosis.

Nothing is so contagious as cheerfulness.

Consumptives should not kiss other people.

A good posture will help us all to face our daily tasks.

Now, isolation is not a cruel thing.

HEALTH HABITS

Destiny Awaits

with this law, you will sometimes see on a house a card with the words: "Scarlet Fever", "Small-pox", or "Diphtheria". This card warns people not to enter the house. It directs that the children in the house must not go to day school or Sunday school, and that the grown-up folk belonging to the house must not mingle with others at bees or threshings, or in shops, factories, street-cars, or in churches.*

Now, isolation is not a cruel thing. It is the kindest thing that can be done when you look at the matter from all sides.

📖

Nothing is so contagious as cheerfulness. If we have it, others will catch it from us. There is no better physician than Dr. Merryman. The medicine he gives us to take is the pleasantest in the world. We have it entirely in our own hands to cultivate a bright and cheerful disposition that will make the world a pleasanter place both for ourselves and others, or to cultivate a gloomy and morose disposition that will make things disagreeable for everybody.

📖

A good posture makes us look and feel at our best and stiffens our courage as well. Idleness often goes hand in hand with a slouchy carriage. We should not be content just to slouch through life, but we should aim high and let our posture reflect our ambitions. A good posture will help us all to face our daily tasks. An erect carriage is not merely healthful, but it also helps us to maintain our self-respect and to command the respect of others. On the other hand, a lounging gait often excites ridicule or mild contempt.

📖

* Consumptives should not kiss other people.

One can preserve fruit by sealing it in jars, for fruit keeps best without air, but one cannot preserve children by keeping them in tightly sealed rooms.

Try to grow a potato in the dark, and you will notice that its leaves are small and whitish, and that its stem is tender and frail. Compare it with a sturdy potato plant from the garden, and you will see how sickly a plant is without the sun. Boys and girls, like plants, must have sunlight, or like plants grown in darkness they will become puny and weak.

One's brain may also be abused by constant work with no recreation and rest. A condition called "brain fag" is the result. A pupil in this state finds himself unable to understand what he is reading. It is very difficult for him to learn even the lessons which he usually finds easy, and he becomes listless and irritable.

After a long winter and the dreary winds and rains of March, spring is always welcome. With his magic wand the sun bids the song birds to return from the South, the buds to open, and the wild flowers to bloom. Sunshine makes the world happy and gay.[*]

The best exercise for growing boys and girls is to be found in play. Canadians have a wonderful variety of sports and games from which to choose. We have only to compare the pale faces and frail forms of the children who are continually coddled behind closed windows and doors in overwarm houses with the ruddy faces and sturdy forms of those who play outside, to see the advantage of an outdoor life.

The muscles of idiots are seldom, if ever, symmetrically developed, because the brain is not perfectly developed and does not, therefore, send out the nerve-impulses which alone will make the muscles grow. Such persons will walk, if they are able to walk at all, with an unsteady or shuffling gait.[†]

📖

[*] But, very often a thoughtless mother may be seen pushing her baby along in its carriage and allowing the strong light of the sun to shine full into its eyes. This is very wrong.

[†] On the other hand, amputation of the leg of an infant is followed by the arrested development of certain parts of the brain.

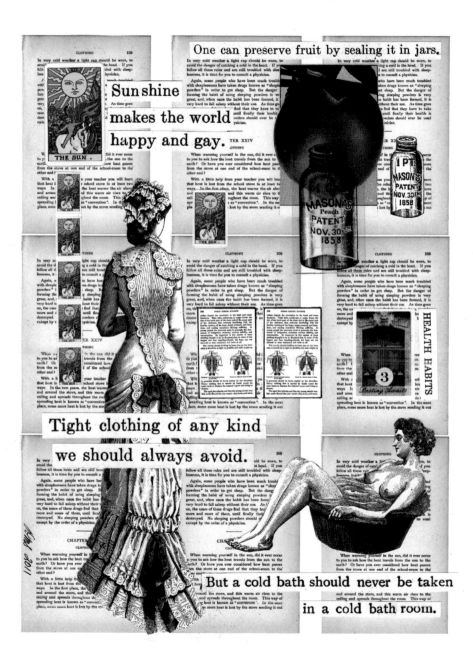

One can preserve fruit by sealing it in jars.

Sunshine

makes the world

happy and gay.

Tight clothing of any kind

we should always avoid.

But a cold bath should never be taken

in a cold bath room.

Swimming is healthful as an exercise, and so is bathing of any kind; but frequent baths in a tub are not what an ordinary boy calls fun. A tub is, naturally, not as exciting as a river or a lake.

Many people take a cold bath every morning, and if this agrees with them and causes a healthy reaction, that is, a general feeling of well-being, and brings the skin to a ruddy glow, it is good for them. If, on the other hand, a cold bath produces a chilly, depressed feeling and a blue-looking skin, it is wiser to avoid it.*

The greatest nations have been the greatest bathers. The Greeks and the Romans had the finest baths in the history of the world—beautiful marble palaces costing fabulous sums of money. The British are a nation of bathers. The Japanese soldiers, during the war between Japan and Russia, resorted to frequent bathing, and by their cleanliness helped to prevent certain diseases from breaking out among them.

Strong people should bathe in cool water (about 80°F) every morning. So should delicate children and aged people if they can stand the cold, but if they cannot they should use tepid water (about 90°F). The best soap should always be used in taking a bath. Bad soap injures the skin.† Once a week before going to bed a warm bath (about 100°F) should be taken. Moreover, for evident reasons, all underclothing should be changed at least once a week and invariably taken off at night and hung up to air.‡

Boys should wash their heads every week. Girls may wash theirs less frequently, for as a rule they seldom get it into the condition requiring such frequent washing as do the more active boys.

* A cold bath should never be taken in a cold bathroom.

† While the skin is a great means of protection, it is not like a suit of armour which protects one against cuts and wounds from swords and knives, nor is the skin able to stop bullets.

‡ The best material for underclothing is wool for both winter and summer. Whether for winter or for summer use, clothing should always be as light as possible. Heavy clothing that is carried by bands round the waist tends to displace the internal organs and bring on disease. Clothing should also be loose. Tight clothing of any kind we should always avoid. Tight boots, tight garters, tight belts, tight collars and tight hats are all harmful.

In most people, the rate of skin growth is about the same as the rate of peeling, and, therefore, the thickness remains the same. This is also true of the bark of some trees, such as the arbutus. But with people who never take a bath, the skin thickens and becomes covered with a crust of dirt as well. This does serious harm to the health, although the harm does not come upon such people all at once. If a person is very strong, it may take years before he suffers very much from allowing his skin to grow thick and dirty. Slowly and surely, however, he will have to pay for his folly.

While cleanliness is a good thing, there is no credit in being always clean. The boy who never has unclean hands is the boy who never plays any strenuous games or does any real work. No one likes the fellow who is afraid to dig in the garden, or go fishing, or play football for fear of spoiling his appearance. Good honest dirt acquired in work or play is not something to be ashamed of; and no one who is worth anything will draw back from a task merely because it will soil his hands.

📖

Of all the influences to which a growing child is naturally subjected, probably the dominating one is food. Next in importance to selecting plain, wholesome, fresh foods, is the duty of seeing that they are well cooked. As regards this, girls must rely upon instructions which they can get from their mothers, and from useful books upon these subjects.

It is fortunate that most boys and girls are blessed with a good appetite. There are some, however, who pick and fuss over their food, who do not like this and will not eat that; thus causing worry to their parents who have done their best to provide good wholesome food.*

Naturally a big boy will need more to eat than a little one. A girl who has been skating or walking will eat more than her sister who has been resting quietly at home all afternoon.

* I do not pretend to say that everyone will enjoy eating beans or peas as keenly as they would meat. The easy-going Southern negro lad prefers a piece of watermelon to the piece of blubber which satisfies the Eskimo lad of the far north.

Some boys and girls would never become very large men or women no matter how much they ate, any more than a canary would become as large as a crow simply by trying to eat as much as the crow.

A word or two may be said here in regard to the act of eating. Some children eat too fast and eat too much, and often as a consequence make themselves sick. Very little liquid should be drunk with meals, unless care is taken to chew the food as long and thoroughly as if no liquid were taken. Our teeth are intended to be used. To keep them healthy we must give them exercise, and the best exercise for them is the chewing of solid foods such as meats and fruits and crusts.

From the time the baby cuts his first teeth to the time when, as a grand-father, he begins to lose them, his pleasure and happiness depend very much upon the condition of his teeth. Beautiful arches of clean sound teeth are among the greatest gifts that nature can bestow upon us; but we must remember that nature gives us this gift to keep only the condition that we take care of it.* Digestion begins in the mouth.

There are many causes of indigestion which it would be useless to dis-cuss in detail with you. Let care, worry, anxiety, sorrow, or any other strong emotion press upon a person, especially upon a delicate person, and at once there start other nerve messages from the brain, which hinder digestion or stop it altogether. Hence the rule that no cares or worries should ever be brought to the table during meal-time.†

📖

A boy who has come into the world with a weak stomach and intestines is badly handicapped in the race of life. Fortunately, there are not many such children. Those who are thus afflicted must always have the special care of mothers, nurses, and doctors.

* The great matter in caring for the teeth is to keep them perfectly clean. The tougher portions of food which become fixed between the teeth should be removed with a quill.

† Constipation is the source of a great deal of misery and suffering in the form of headaches, tiredness and giddiness.

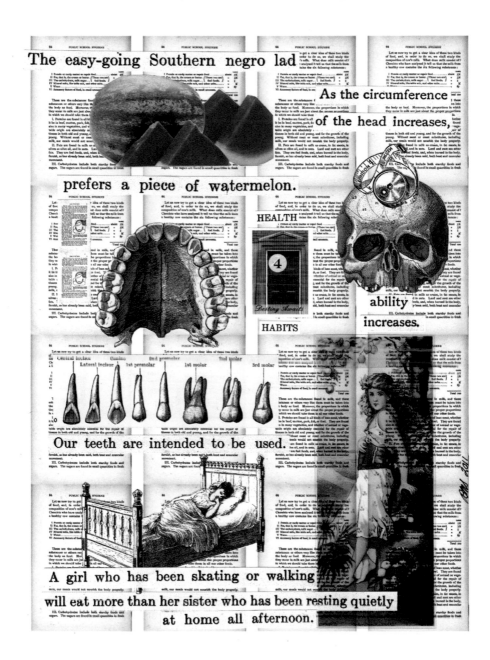

The easy-going Southern negro lad

As the circumference

of the head increases,

prefers a piece of watermelon.

HEALTH

ability

increases.

HABITS

Our teeth are intended to be used.

A girl who has been skating or walking

will eat more than her sister who has been resting quietly

at home all afternoon.

Some people are blessed with having been born strong. On the other hand, there are babies who are born with weak bodies, and especially with weak bones. As a rule, strong parents have strong children and sickly parents have delicate children. Sometimes, however, it happens that a puny child is born to sturdy parents and a fairly strong child to weakling parents.

Remember that the following statements are based upon the average of a large number of measurements of boys and girls. There must, therefore, be children who are exceptions to the general rules here laid down; for example, some big-headed boys learn slowly, while some small-headed boys are very bright and quick in their studies.* But apart from such exceptions, the general statements hold good. These are as follows:

1. As the circumference of the head increases, ability increases.
2. The children of intelligent people have a larger circumference of head than the children of the ignorant.
3. Bright boys are taller and heavier than dull boys.
4. Children of intelligent people have greater height, weight, and length of body than children of the ignorant.
5. Children of intelligent people show greater ability in their studies than children of the ignorant.

These facts seem to mean that the children who are best fed, best clothed, and best housed, will, as a rule, have the best chance to get on in the world; whereas, poorly fed, ill clad, and poorly housed children can hardly ever hope to be more than hewers of wood and drawers of water for others.

📖

* Many pupils have been thought to be very stupid, whereas the real trouble was that they had poor eyesight and could not see clearly what was written on the blackboard.

Of course you have all heard of whisky, brandy, beer, ale, and wine, and have probably seen these liquors.* They differ from one another in colour and taste, but resemble one another in having a disagreeable taste; at least they are all at first disagreeable.

Most people have noticed that a drunken man usually says foolish things and does foolish things. He thinks he can run faster, jump higher, work harder, write better, or count faster, with the aid of alcohol than without it. But this is all pure fancy. As to the use of his muscles, in either work or play, every one knows, who has ever seen a drunken man, that, instead of being able to use his muscles properly, he can scarcely use them at all.

A person under the influence of alcohol becomes dangerous, just as a speeding motor car is dangerous when its brakes are out of repair and fail to hold the car.

As everyone knows, some people drink whisky or brandy in cold weather because they think it makes them warm. Those who travel in arctic regions nowadays never drink alcohol in order to keep warm. Dr. Carpenter tells about a crew of sixty-six men who left Denmark and wintered in Hudson Bay. They took an abundant supply of alcohol with them, thinking that it would help them to keep warm. By the end of the winter they were all dead but two men, because the alcohol had destroyed the power of their bodies to regulate their temperature. The effects of alcohol, therefore, are bad, whether we drink it in winter or in summer.

Bad as the effects of alcohol are upon the drunkard himself, the effects upon his children are very much worse. They are often left without food, clothing, and education; but these are small ills compared with the supreme one which a drunkard sometimes brings upon his innocent offspring, namely, insanity. The almost unvarying testimony of medical superintendents of lunatic asylums is that the drunkenness of fathers or mothers often entails upon children enfeebled brains and nerves, with the result that, when the strain and stress of adult life come

* Fortunately, Canadian children seldom drink wine or beer; but in some of the European countries it is different. One of the evil results is that even in small quantities it dulls their minds.

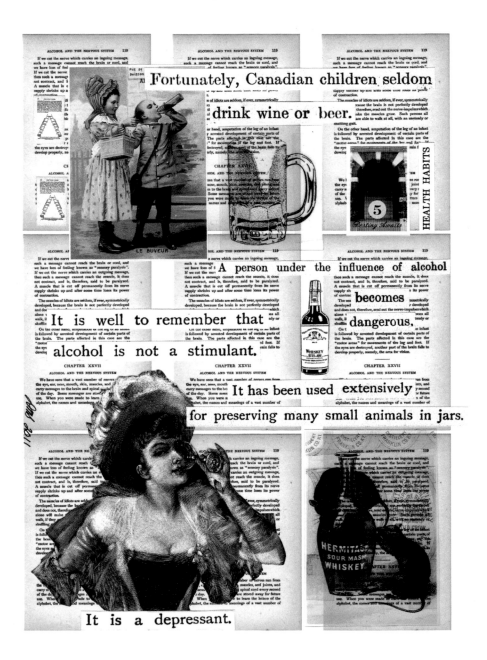

Fortunately, Canadian children seldom drink wine or beer.

HEALTH HABITS

A person under the influence of alcohol becomes dangerous.

It is well to remember that alcohol is not a stimulant.

It has been used extensively for preserving many small animals in jars.

It is a depressant.

The image contains text.

upon them, brain and mind break down and they become inmates of lunatic asylums.[*]

📖

In case of an accident, every boy and girl should know what to do before the doctor comes. A boy who is quick to think and quick to act may often be of great service to one who is bleeding profusely, or who has taken poison, or who is unconscious and almost dead from being under water.

When taken from the water, a person should first be turned face downward and held up by the middle with his head low, in order to allow the water to run out of his mouth and lungs. Loosen the collar quickly, but do not take time to remove the clothing.

When common household poisons, such as paris green, fly poisons, corrosive sublimate, paregoric, soothing syrup, ends of matches, are taken by accident, the first thing to do is to send for a physician. While waiting his arrival, however, it is generally advisable to induce vomiting. This may be done by giving a teaspoonful of mustard in a glass of warm water.[†]

Carelessness accounts for the greatest number of accidents. For example, before crossing a street made dangerous by motor traffic, some boy fails to look both ways to see if the road is clear before stepping off the curb. Just as he does so he is struck by a passing car. A little care on his part would have prevented this. Bravado is responsible for many accidents among schoolboys. Playing tricks on others is the cause of many injuries. Ignorance also accounts for many accidents.

If a vein is cut, the blood will be darker in colour than the lighter coloured blood from an artery. If the wound has been made with a dirty knife, tin can, rusty nail, or glass, it should be thoroughly washed with clean, boiled water before being bandaged. In such wounds, especially if

[*] It is well to remember that alcohol is not a stimulant. It is a depressant. It has been used extensively for preserving many small animals in jars.

[†] For opium poisoning, keep the patient walking about and give frequent drinks of strong coffee.

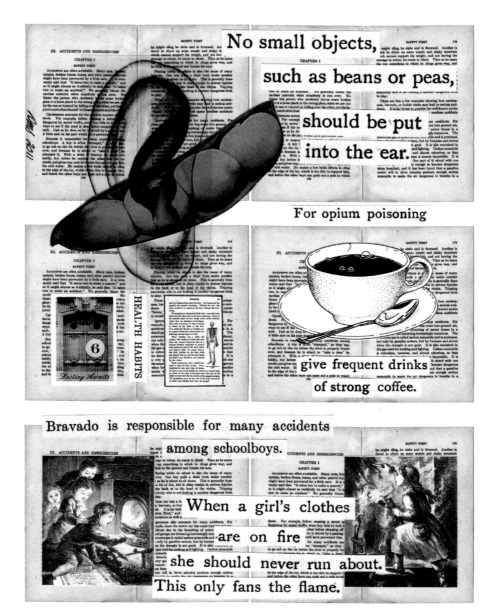

No small objects,

such as beans or peas,

should be put

into the ear.

For opium poisoning

HEALTH HABITS

give frequent drinks

of strong coffee.

Bravado is responsible for many accidents

among schoolboys.

When a girl's clothes

are on fire

she should never run about.

This only fans the flame.

any soil has been carried deeply into the wound, or if the wound is of such a character that it cannot be thoroughly washed out, there is danger of the development of lock-jaw. Tetanus antitoxin should be given in all such cases by your doctor.[*]

A foreign body in the nose, such as a shoe button, may be removed by blowing the nose rather vigorously. If that does not remove it, wait until you get home and have your parents or the doctor attend to it.[†]

No small objects, such as beans or peas, should be put into the ear. A foreign body in the ear should be left for the doctor to remove. It is dangerous to tamper with anything in the ear. If an insect should get into it, a little water or olive oil poured in will generally suffice.

When a person suddenly falls over unconscious and his face looks very white, he has probably fainted. This may be due to the stuffy air in the room, to an injury, a shock, or even to the sight of blood.[‡] Strong ammonia or smelling salts should not be held to the nose of a person who is in a faint. It is very irritating and, as a rule, does no good.

Some people are subject to fits, and when they have them they fall unconscious, roll their eyes, and they may also foam at the mouth. Their faces are not white as in fainting, but become red or almost purple in colour. Fortunately, these distressing fits are rarely dangerous.

One more important fact must be noted here. When a girl's clothes are on fire she should never run about.[§]

[*] This antitoxin is supplied by the Provincial Government free of charge.

[†] The nose is of great use to us in other ways than in enabling us to smell. It warms, moistens and filters the inspired air. For example, when we are travelling in dusty cars, the nose stops much dust from passing down the throat and into the lungs. The dust gathers in a ring at the entrance to the nostril. The same thing may be noticed in men who have been working close to a threshing machine or who have been shovelling coal.

[‡] No one needs to be told what blood looks like.

[§] This only fans the flame.

AROUND THE WORLD IN 100 POSTCARDS:

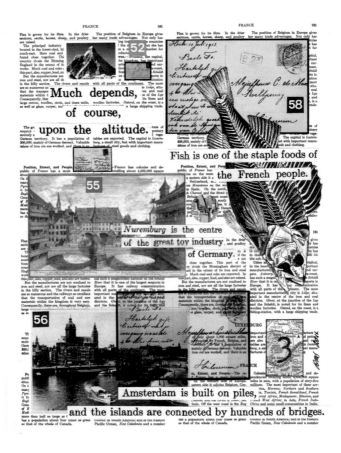

IN WHICH THE GEOGRAPHER MAKES A SURVEY OF THE WORLD, FINDS IT WANTING, COMES TO THE CONCLUSION THAT THERE'S NO PLACE LIKE HOME

From:

Ontario Public School Geography
Authorized by The Minister of Education for Ontario
Twenty-second Edition
(Toronto: W. J. Gage & Company, 1946)

In the Preface to this edition, the unnamed author or authors note that: "There are few subjects in which text books become so quickly out of date as in Geography. In order to ensure accuracy, the Department of Education and the Publishers have revised the Ontario Public School Geography at frequent intervals as events demanded. The most recent revision has necessarily been confined to the sections dealing with North America, because war conditions have made it practically impossible to obtain authentic information regarding many countries of the world."

Every report of the trip gets it more and more wrong.
When you talk to someone about it, the experience is
altered. Keeping quiet changes it too, differently. There
can be no report.

—Elias Canetti, *Notes from Hampstead*

1. **NOW LET US MAKE A SURVEY OF THE WORLD.**

2. We have chosen the aeroplane for our trip because it is so fast and
because we can see much more from high in the air. Now we must
prepare ourselves for the most dangerous and thrilling flight of all.
What a wonderful sight to see the clouds swirling below us, while we
fly in dazzling sunshine above them!

3. The earth is a huge sphere. If we could view it from high up in the sky,
it would appear circular, like the sun or the full moon. As we can see
only a very small portion of its surface when we are standing on it, it
seems flat to us. Yet we know for certain that it is round. Men have
travelled right around it.

4. Have you ever travelled 100 miles by train? Can you imagine trav-
elling in a fast train, day and night, without a stop, for three weeks?
Your train would need at least twenty whole days to complete a jour-
ney round the world, if such a journey were possible.

5. The total length of the Canadian National Railways is 21,847 miles. Thousands of men work on the railways.

6. You have seen a top spinning on the floor. The earth also rotates. Let us think of the earth as a huge top, spinning along on an invisible floor. Do you find this hard to believe, and do you wonder why we do not feel the movements of the earth?

7. When it is daytime with us, it is night on the other side of the world.

8. We speak of the land as *terra firma*, that is, the solid land. No matter where you live, if you dig deep enough, you will come at last to solid rock. Give the reason for this.

9. Land heats more quickly than water and to a far higher temperature, when exposed to an equal amount of sunshine. If you have lain upon a river bank or lake shore after swimming, you will agree that this is true.

10. You have often seen washing put out on the line to dry. The clothes, even after being wrung out, are still wet to the sight and to the touch. But, as you know, after an hour or two in the air and sunshine, they are quite dry.

11. You have doubtless noticed the little beads of moisture that, on a hot summer day, gather on the surface of a pitcher filled with cold water. Probably you have wondered what caused them to gather there.

12. It may seem to you that nothing can be more variable than the wind. The air is never still. The winds, as you have seen, hold within their grasp the power to make a garden or a desert.

13. Scorpions are numerous in the desert.

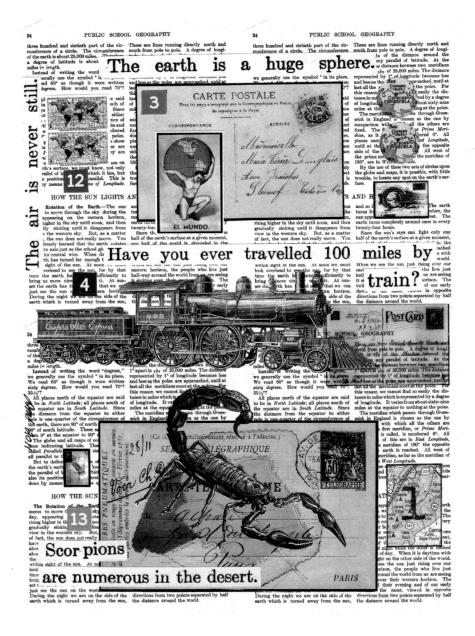

14. You have read of the monsoons of Asia. They bring with them the priceless gift of rain. Before the summer monsoons begin to blow, the fields of India and China are parched and dry. Then comes the wind from the great oceans. The rain falls heavily over the land and waters the crops which nourish hundreds of millions of people. Unhappy, indeed, is the land when the monsoons are weak! Then the crops fail, and famine takes its toll of the crowded population.

15. We speak also of the restless ocean, and with equal reason. A thorough knowledge of the tides is necessary for every practical navigator.

16. You can make sea-water in your own home. Buy a package of sea-salts at the drugstore. Add one spoonful of the salts to about twenty-four spoonsful of fresh water. Stir the water around until the salts have disappeared.

17. There is no worse fate for a sailor than to be cast adrift in a small boat without a supply of fresh water.

18. The array of animal life which the ocean presents is so vast that we cannot hope to learn more than a very little about it.

19. Find the Arctic Ocean on the globe. In the Arctic seas are whales, narwhal, walrus, and seals, as well as fish. The hide of the walrus makes magnificent leather.

20. Most of us, however, are more interested in the common oyster, which is so delicious as food. Fortunately, oysters multiply very rapidly. A single oyster lays from 16,000,000 to 60,000,000 eggs in one season.

21. Far to the north live the Eskimos. In winter their land is very cold. Blizzards sometimes rage for days together. Fresh water is obtained from melted ice and snow. Some meat is frozen and then eaten raw.

The Eskimo has little furniture in his house. The Eskimos are a happy people.

22. Before the white man came to America, the Indians hunted over the whole continent. The life of the Indians is not easy. They often suffer from the long winter, for when blizzards come up, they cannot get out to hunt for food. When the Indians get injured or are sick a long distance from a trading-post, there is no one to help them. At the best, tramping many miles every day on snowshoes or paddling heavily laden canoes up swift rivers is hard, tiring work.

23. In spite of these hardships, the Indians are in many ways better off today than they used to be. They have plenty of warm furs and blankets to wear. Good furs, as you know, are very valuable. Often he catches a lynx, a marten, a fox, a mink, an otter, or a beaver. Muskrats are trapped in the spring. Occasionally a trapper gets a shot at a wolf. He is very glad to shoot a caribou, a moose, or a deer, for the flesh of these animals is very palatable, and their hides make excellent moccasins and other clothing.

24. The bears sleep in their dens all winter.

25. Do you remember the bright star which guides the Indians by night?

26. Perhaps you can also see the white glint of a sail. It belongs to a fishing schooner.

27. The life of the fisherman is also dangerous and hard. They catch many varieties of fish, such as herring, halibut, haddock, and cod. This is back-breaking work. In the evening the dories return to the schooner with the day's catch. If the season has been good, their holds are crammed with thousands of codfish. With the money received for the fish, the fisherman can buy almost anything he wants. He can have

good furniture and pretty pictures in his home. He can have books to read, a piano, a phonograph, or a radio to give him music, or, in fact, anything else he likes.

28. A deep, fertile soil is best for farming. Where, in general, are the best farms found?

29. The principal exports from Canada are agricultural products, particularly wheat, oats, vegetables, fruit, meat, hides, bacon, butter, cheese, and eggs; products of the fisheries, such as fresh fish, canned salmon, lobsters, and sardines; mineral products, principally gold, silver, nickel, copper, asbestos, and mica; forest products, such as dressed lumber, shingles, laths, wood-pulp, and paper; and furs, both raw and dressed.

30. The forests of Canada are the home of wild animals of many kinds. The moose is common in every part of the northern forest. Among the smaller flesh-eaters, the fisher, the marten, the weasel, the ermine, the mink, the skunk, and the otter are found everywhere.

31. The prairies were once the home of large herds of bison, or buffalo, as they are more usually named. As late as 1858, a traveller upon the western plains drove for ten days through a single continuous herd, and the prairie was black with moving animals as far as the eye could reach. But man needed for his own use the land over which they roamed.

32. On the whole, the summers of Ontario are delightful. The winters are dry and exhilarating, with many days of unclouded, sunny skies and clear, bracing air.

33. The city of Toronto is noted for its splendid residential sections of well-built homes, spacious lawns, and fine old trees. It is a busy city.

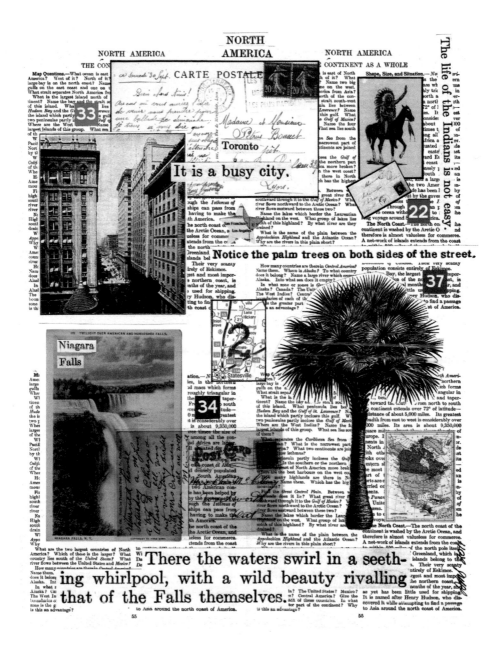

34. The Niagara River carries the waters of Lake Erie to Lake Ontario. Below the Falls the river runs very rapidly between steep cliffs. At one place it is compressed to a width of 300 feet between cliffs of rock 200 feet high. There the waters swirl in a seething whirlpool, with a wild beauty rivaling that of the Falls themselves.

35. The United States, so far as its natural resources and its manufacturing facilities are concerned, is probably the most self-contained nation in the world today.

36. Manufacturing has not been one of the leading industries of Mexico. For this the ignorance and the laziness of the people are partly responsible, but the main reason is the absence of coal.

37. In Puerto Rico, there is little manufacturing, except sugar, cigars, and cigarettes. In the towns, notice the palm trees on both sides of the street.

38. The population of Central America is made up of whites of Spanish descent, Indians, and half-breeds. There are many Negroes. The Spanish language is spoken, and Spanish customs prevail. Progress has been much hindered by the ignorance of the people and by the unstable character of the governments. The cities and towns are not large, and there are but few that are worth mentioning.

39. What is the name of the narrow land bridge connecting North and South America?

40. In South America, the Indians eat the tails of young alligators, and travellers who have tasted this dish speak well of it. Turtles are extremely abundant, and many of them are very large. Their flesh is good to eat.

41. Rio de Janeiro has a magnificent harbour. Buenos Aires is very beautiful. Bogota is a modern city and enjoys a delightful climate.

42. What ocean separates Europe from North America?

43. Europe has long been the home of the most highly civilized races in the world. Her peoples have long been foremost in industry, commerce, science, and art. Europe's importance is due chiefly to the fact that it is the home of the white peoples of the world. The white races have proved themselves superior to all others in many ways. They are more eager to acquire knowledge and to put it to practical use. They are more energetic. They have a greater capacity for organization, which is one of the chief characteristics of civilized man.

44. The temperate zones are best suited to white men.

45. Britain has never tried to exploit ignorant savages, but has treated them with kindness and justice, so that they have benefited by her rule.

46. Great Britain is the largest island in Europe and the most important island in the world. It is not hard to understand why Britain is the commercial mistress of the world. Brewing and distilling give employment to many people, while jams, marmalades, pickles, and sauces are produced in large quantities.

47. Sheffield is noted for its cutlery.

48. The Irish peasant eats seaweed as a relish with his potatoes.

49. The Norwegians are an intelligent and industrious people. The hardships and privations of their life on the sea and in the mountains have made them strong and vigorous.

50. In Sweden, the making of matches is a thriving industry.

51. About half of Switzerland is occupied by mountains. Like most mountaineers, the people of Switzerland are devoted to their homes and to their country. They are, for the most part, strong in body, cheerful and happy in their homes, good farmers, and excellent workmen. The Swiss are shrewd and industrious.

52. Much depends, of course, upon the altitude.

53. Swiss clocks and watches are famous for their excellence.

54. Austria does not grow enough grain and vegetables to feed her people. Vienna is delightfully situated on the Danube.

55. The forested area of Germany is large. Everywhere in Germany much attention is paid to the raising of horses, sheep, cattle, and poultry, and to the making of butter and cheese. Nuremberg is the centre of the great toy industry of Germany.

56. Amsterdam, built on a group of swampy islands at the south end of the Zuiderzee, is the largest city in the Netherlands. It is built on piles, and the islands are connected by hundreds of bridges.

57. Paris is the political, industrial, literary, scientific, and artistic centre of France. It is a very beautiful city, with wide streets, boulevards, and parks, with beautiful churches, such as the Cathedral of Notre Dame, art galleries, such as the Louvre, handsome public and private buildings, triumphant arches and monuments.

58. Fish is one of the staple foods of the French people.

59. All over the island of Corsica grow the olive and the chestnut, the nuts of the latter being the chief food of a large part of the population.

60. Industrially, Spain and Portugal are not progressive nations. For this the people themselves are largely responsible.

61. Gibraltar is a lofty, strongly fortified rock.

62. We are accustomed to think of Italy as a perpetual summer land of flowers and fruit. Wine is one of its most important products. Macaroni, cheese, olive oil, straw hats, lace, and coral jewellery are other leading manufactures.

63. Eggs are exported from Russia in very great numbers. The northern part of Russia is unproductive.

64. The Yugoslavians are a thrifty, hard-working people, fond of bright-coloured, picturesque costumes, music, and festive gatherings. The country has numerous railways.

65. The Albanians are the most ancient people in Southeastern Europe and are distinguished for their passionate love of country and for their refusal to mix with other races.

66. The people of Bulgaria are industrious, but somewhat war-like.

67. The Greeks have always been sailors and traders, frugal, energetic, and industrious. Modern Athens is beautifully planned, with boulevards, trees, and open spaces.

68. Seen from a distance, Istanbul is the most beautiful city in Europe. It is, however, a very dirty place, with large slum districts.

69. What two seas are between Asia and Europe?

70. The most useful animal of the Tibetan Plateau is the yak.

71. Sponges are obtained from the Aegean Sea.

72. The chief exports from Palestine are oranges, lemons, wine, olive oil, and laundry soap.

73. The Afghans, about twelve million in number, are all Mohammedans. They are a very brave but very cruel race.

74. The Arabian horse is celebrated for its beauty and its speed. However, there are but few places of any importance in Arabia.

75. In China, there is not even sufficient wood to make coffins for the dead, and the most valued gift that a son can make to his parents is a coffin.

76. Japan is very hilly.

77. The people of Japan are largely Mongolians. They are industrious and skillful, excelling especially in work requiring delicacy of touch and handling. They are an intelligent people, and though they retain many of their picturesque customs, they have learned much from their association with western nations and have adopted many of their practices. Japan now has railways, telegraphs, telephones, factories, schools, and universities.

78. Rice is the main grain crop of Japan. How large do you think Japanese farms are? The farms are so small that the farmer cannot grow much more than his own family needs. The little he can sell does not bring him much money. But his wants are few. He and his children are half naked, and his wife usually wears only a plain blue cotton dress.

79. Name the isthmus which joins Africa and Asia.

80. Africa is very large.

81. In the forests live many strange animals. There are huge apes and monkeys, stronger than the strongest men. Herds of elephants roam through the forest. Hippopotami and crocodiles live in the rivers and marshes. The hippopotamus is a large, ungainly animal with a huge head and a wide mouth. The crocodile is much more dangerous. Many Negroes are caught by crocodiles.

82. In the country of the Negroes there is plenty of rain, and the sunny days are long and hot. Therefore all the plants there grow very large. Many of the trees are enormous. Their foliage is so thick that little light or sunshine can get through.

83. The Negroes live in a land of plenty. The Negro can grow all the food he needs with no tool but a hoe. They have fields of sweet potatoes. The Negro is warm enough without any clothing. They do not need warm houses. Among the Negroes the women alone do the work.

84. People seldom work harder than they must.

85. Somaliland is one of the least known parts of Africa. This is due to the unattractive nature of the country and the fierce and treacherous character of the natives, all fanatical Mohammedans. Except for its game, including giraffes, zebras, antelopes, and gazelles, the land has little interest or value for the white man.

86. In Abyssinia, it is said, men carry about little sticks of rock-salt and suck them, just as Canadian children suck sticks of candy. When an Abyssinian gentleman meets a friend, he offers him his salt-stick to lick. He can imagine no finer treat.

87. People who, like the white races, have learned much, are called civilized, to distinguish them from uncivilized or barbarous people like the African Negroes.

88. Civilized man requires a very great quantity of iron.

89. The aboriginal inhabitants of Australia are a peculiar race, somewhat resembling the Negro.

90. The sun beating down upon the naked earth makes the Great Australian Desert one of the hottest places in the world.

91. The most hated animal in Australia is the dingo.

92. The average full-grown kangaroo measures about five feet from the tip of its nose to the base of its tail, and may weigh as much as two hundred pounds. The tail measures about four and a half feet.

93. The Maoris, as the natives of New Zealand are called, at first gave some trouble, but this has long since passed away.

94. Here in New Zealand are pools of boiling mud, which now and again send a column high into the air; here are lakes of hot water; here you may walk over land through which steam is bursting everywhere.

95. There is another great mass of land far to the south. It is called the *Antarctic Continent*. It is as yet quite useless to man.

96. What is the only direction in which a man can look when he is standing at the south pole?

97. Location is always a matter of comparison with some place whose situation we know. What is the reason for this?

98. There are two essential things to remember. Name them.

99. We Canadians have the privilege of owning almost half of our great continent. This means that we are among the most fortunate people of the world. Each one of us should strive to realize how great a thing it is to be a citizen of Canada. Each one of us should have a thorough knowledge of all those things which make Canada, though so young a nation, second to none either in past accomplishment or in future prospect. No other of our geographical studies is so important or nearly so interesting as the study of our own land.

100. Keep in mind these important facts.

A Note On The Illustrations

Many of the images in these collages were taken from volumes published by Dover Publications, Inc., Mineola, New York:

120 Great Impressionist Paintings (Carol Belanger Grafton);
120 Great Paintings of Love and Romance (Carol Belanger Grafton);
120 Italian Renaissance Paintings (Carol Belanger Grafton);
286 Full-Color Animal Illustrations: Jardine's "Naturalist's Library" (Sir William Jardine);
600 Butterflies and Moths in Full Color (W. F. Kirby);
3800 Early Advertising Cuts: Deberny Type Foundry (Carol Belanger Grafton);
Animals: A Pictorial Archive from Nineteenth-Century Sources (Jim Harter);
Antique Playing Card Designs (Carol Belanger Grafton);
The Art of Tarot Cards (Alan Weller);
Bloomingdale's Illustrated 1886 Catalog;
Butterfly Garden Stickers (Patricia J. Wynne);
Children: A Pictorial Archive from Nineteenth-Century Sources (Carol Belanger Grafton);
Early Illustrations and Views of American Architecture (Edmund V. Gillon, Jr.);
Everyday Fashions of the Twentieth Century (Tom Tierney);
Food and Drink: A Pictorial Archive from Nineteenth-Century Sources (Jim Harter);
Full-Color Men and Women Illustrations (Carol Belanger Grafton);
Full-Color Old-Time Animals (Carol Belanger Grafton);
Handbook of Early Advertising Art (Clarence P. Hornung);
Hands: A Pictorial Archive from Nineteenth-Century Sources (Jim Harter);
Harter's Picture Archive for Collage and Illustration (Jim Harter);
Heck's Pictorial Archive of Nature and Science (J. G. Heck);
Historic Alphabets and Initials (Carol Belanger Grafton);
Historic Costume in Pictures (Braun and Schneider);
Human Anatomy for Artists (Dr. J. Fau);
The Illustrations from the Works of Andreas Vesalius of Brussels;
Illustrations of World-Famous Places (Charles Hogarth);
Jordan, Marsh Illustrated Catalog of 1891;

Men: A Pictorial Archive from Nineteenth-Century Sources (Jim Harter);

Montgomery Ward & Company 1895 Catalogue;

Music: A Pictorial Archive of Woodcuts and Engravings (Jim Harter);

Old-Fashioned Animal Cuts (Carol Belanger Grafton);

Old-Fashioned Eating and Drinking Illustrations (Carol Belanger Grafton);

Old-Fashioned Illustrations of Books, Reading and Writing (Carol Belanger Grafton);

Old-Fashioned Romantic Cuts (Carol Belanger Grafton);

Old-Fashioned Transportation Cuts (Carol Belanger Grafton);

Old-Time Frames and Borders in Full Color (Carol Belanger Grafton);

Old-Time Trade Cards (Carol Belanger Grafton);

Old-Time Travel Posters and Luggage Labels (Carol Belanger Grafton);

Picture Sourcebook for Collage and Decoupage (Edmund V. Gillon, Jr.);

Plants: 2400 Copyright-Free Illustrations of Flowers, Trees, Fruits, Vegetables (Jim Harter);

Redouté Flowers and Fruits (Pierre-Joseph Redouté);

Victorian Color Stickers (Carol Belanger Grafton);

Victorian Romantic Stickers and Seals (Carol Belanger Grafton);

Victorian Women's Fashion Cuts (Carol Belanger Grafton);

Victorian Women's Fashion Photos;

Vintage New York City Views;

Women: A Pictorial Archive from Nineteenth-Century Sources (Jim Harter).

Other sources of the collage images include:

ARTchix Studio (artchixstudio.com);

Bmuse Products for Creativity (b-muse.com);

The Complete Encyclopedia of Illustration (J. G. Heck; Gramercy Books, NY);

Food Art: Volumes 1 and 2 (Graphic Source Clip Art Book Library, Wheeling, IL);

Images of Medicine: A Definitive Volume of More than 4,800 Copyright-Free Engravings (Jim Harter; Bonanza Books, NY);

Mamelok Press Scrap Art (mamelok.com);

More Ephemera! (Beth Cote; Design Originals, Fort Worth, TX);

Tim Holtz Salvage Stickers: Crowded Attic (timholtz.com);

Wikimedia Commons (commons.wikimedia.org);

The Wonderful World of Ladies' Fashion (Joseph J. Schroeder, Jr.; Digest Books, NY).

All images used are in the public domain and copyright-free.

ACKNOWLEDGEMENTS

SOME OF THESE STORIES and pictures have been previously published.

"A Nervous Race" appeared in *The New Quarterly* No. 114, Spring 2010, Waterloo, Ontario.

"A Body Like A Little Nut" appeared in the *Queen's Quarterly* Fall 2011, Kingston, Ontario.

"History Becomes Authentic" appeared in *Exile: The Literary Quarterly* Vol. 34, No. 1, July 2010, Toronto, Ontario.

"Consumptives Should Not Kiss Other People" appeared in the online journal *Drunken Boat* No. 15, May 2012. http://www.drunkenboat.com/db15/diane-schoemperlen

"Around the World in 100 Postcards" appeared in *Rampike* Vol. 22, No. 1, Spring 2013, Windsor, Ontario.

Many thanks to the editors of these journals for their interest and enthusiasm. I would also like to thank the Ontario Arts Council and their recommenders for ongoing financial support of this project through the Writers' Reserve Program.

Thanks from the bottom of my heart to Daniel Wells and everyone at Biblioasis for their thoughtful care and handling of this "damn thing." Thank you, Dan. Thank you, Tara Murphy. Thank you, Chris Andrechek. Thank you, Kate Hargreaves. Thank you, Jesse Eckerlin. Working with all of you has been a great pleasure and I'm proud to be able to count myself part of the brilliant Biblioasis bunch.

Thank you as always to my beloved agent and friend, the inimitable Bella Pomer.

BORN AND RAISED IN THUNDER BAY, Ontario, Diane Schoemperlen has published several collections of short fiction and three novels, *In the Language of Love* (1994), *Our Lady of the Lost and Found* (2001), and *At A Loss For Words* (2008). Her 1990 collection *The Man of My Dreams* was shortlisted for both the Governor General's Award and the Trillium Award. Her collection *Forms of Devotion: Stories and Pictures* won the 1998 Governor General's Award for English Fiction. In 2008, she received the Marian Engel Award from the Writers' Trust of Canada. In 2012, she was Writer-in-Residence at Queen's University. She lives in Kingston, Ontario.